STILLWATER
MINNESOTA

STILLWATER
MINNESOTA
· A BRIEF HISTORY ·

HOLLY DAY AND SHERMAN WICK

THE
History
PRESS

Published by The History Press
Charleston, SC
www.historypress.net

Front cover, top: The St. Croix Collection; bottom: Sherman Wick.
Back cover: The St. Croix Collection; inset: the St. Croix Collection.

First published 2016

Manufactured in the United States

ISBN 978.1.46713.516.0

Library of Congress Control Number: 2016941426

*To the memory of Sherman Wick (1911–1970),
and for the next generation: Wolfgang, Astrid, Johnathan and Charlie.*

CONTENTS

PREFACE

After reading hundreds of regional history texts, I saw a priceless opportunity offered by this book: I reconnected with my own history. My grandfather Sherman Wick was born in South Stillwater (later Bayport) on the anniversary of Minnesota's statehood (May 11, 1911), the only child of Swedish immigrants. The Andersen Windows machinist also played the clarinet with the Carl Meister Band and appeared in a John Runk photograph on the back cover of Patricia Condon Johnston's *Stillwater: Minnesota's Birthplace* (1995 edition). Sadly, he died weeks before my birth. But reading Stillwater and Bayport newspapers on microfilm created new memories of departed family members, whether the announcement for my late father's eleven-pound birth, or my great-grandmother's almost-weekly social meetings and church choir practices.

Like thousands of others, they lived through times of transition and made Stillwater a better place. And somehow, the vision of political leaders and regular citizens created an idyllic identity.

—Sherman Wick

ACKNOWLEDGEMENTS

W e must acknowledge the wealth of Stillwater area historians: James Taylor Dunn, Augustus B. Easton, E. L. Roney, William H.C. Folsom, Patricia Condon Johnston, Donald Empson and Brent T. Peterson.

Thank you to those who made this book possible—especially the Stillwater Library and the St. Croix Collection.

And thanks to the supporters of the previous book, *Nordeast Minneapolis: A History*, in particular: Terry Storhaug, Walt Sentryz, the managers of independent and chain bookstores and to our community librarians, especially Svetlana Pavlona and Ernie Batson.

Finally, this book would be impossible without the support of our family.

INTRODUCTION

In Stillwater, the balance between economic and ecological riparian interests has evolved. At the head of Lake St. Croix, the St. Croix River transported lumber (1844–1914), steamboats, people and goods and later served as a scenic recreational waterway. After the first settlers disembarked, the purpose of the river shifted dramatically.

Territorial governor Alexander Ramsey referred to "the opulent valley of the St. Croix" in 1852, when the U.S. federal government and settlers recognized the economic potential of the river. Eastern capitalist boosters and New England lumbermen were attracted to the white pine industry. For millennia, the American Indians recognized the bounty of nature and modified the lands—as a hunting ground—to the ethnocentric exasperation of Europeans. The seemingly infinite raw materials spurred industrial development in Minnesota, supplying timber for the rapid westward expansion.

Joseph R. Brown (1805–1870) founded Dacotah, north of Stillwater in Wisconsin Territory, in 1839. The unofficial courthouse was the two-story Tamarack House—aptly succeeded by a sawmill. John McKusick named Stillwater after his hometown in Maine. In 1844, logging commenced.

After Wisconsin's statehood on May 29, 1848, boundaries bisected the St. Croix Valley. In response, the Stillwater Convention drafted a proposal for Minnesota Territory on August 26, 1848, and Minnesota became the thirty-second state on May 11, 1858. Stillwater, one of three major cities in the territory, was selected for the state penitentiary.

Settlers first came into the area by steamboat but, eventually, the first train arrived on December 1, 1870. Stillwater's burgeoning population necessitated a span to Wisconsin. A pontoon toll bridge was completed on May 9, 1876, but immediately proved insufficient. The "new bridge"—the Stillwater-Houlton Interstate Lift Bridge—was not completed until July 1, 1931.

Over the decades, local, state and federal legislation protected the natural resources of the St. Croix Valley. In 1968, the federal government enacted the Lower St. Croix Wild and Scenic Rivers Act, which originally included the Upper St. Croix River and was extended north of Stillwater in 1972, and finally included the remainder to the south as a recreational area in 1976. Today, Twin Cities' urbanization threatens the river.

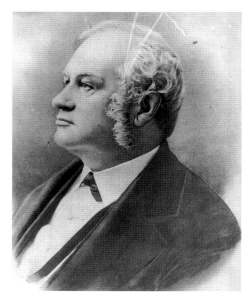

Territorial governor Alexander Ramsey was one of Stillwater's first boosters. *The Minneapolis Collection.*

In Stillwater, the bridge controversy is a continual debate—lawsuits, judicial decisions and federal agencies interfered with construction. Finally, the completion of the multi-lane freeway-style St. Croix Crossing is slated for the fall of 2017.

The question remains: How will the new bridge change Stillwater? As Eileen M. McMahon and Theodore J. Karamanski in *North Woods River* wrote, "While in art and literature rivers often serve as symbols of hope, historically they have always been agents of change."

1

"THE OPULENT VALLEY
OF THE ST. CROIX"

The shores of this Lake [St. Croix] *are the most picturesque of any lake of the size I have witnessed. A dozen or 20 mounds rising in a sugar loaf or pyramid form, may be seen at one glance, covered with the most beautiful carpet of green, with hardly a shrub. The river banks are alluvial and covered with a rich growth of maple, elm, walnut, ash, iron-wood, and butternut, prevail. Many rivulets come in on the east, but one considerable stream* [Apple River] *on the right. White pines appear this p.m. and occasional small prairies. Sand and stony bottom alternate in the stream. Our march today has been 35 to 40 miles. Saw wild geese, tracks of deer and bear, also.*
—*Reverend William T. Boutwell,* Schoolcraft's Expedition to Lake Itasca

Stillwater's location, at the northern edge of Lake St. Croix, determined its development. For American settlers, accessibility to waterpower was essential. Norene A. Roberts, of the Army Corps of Engineers, wrote in "Historical Reconstruction of the Riverfront: Stillwater, MN": "The story of Stillwater has three main ingredients: transportation, lumbering, and manufacturing. Transportation was the pre-requisite of the growth of the latter two." The river spurred development for European Americans. The American Indians also modified the St. Croix—overwhelming evidence is in the archeological record of artifacts and earthworks.

Successive American Indian cultures existed in the St. Croix Valley. Constance M. Arzigian and Katherine Stevenson wrote in *Minnesota Indian Mounds and Burial Sites*, "Precontact earthworks are common throughout

much of eastern North America. Originally they numbered in the tens of thousands, perhaps even a hundred thousand." The authors estimated over one thousand "recorded" earthworks in Minnesota. After farming and urbanization, eighty-six "well documented" mounds are extant—75.9 percent tested positive for human remains. Woodland culture (1000 BCE–500 CE) was characterized by basic subsistence, trade and ceramics—with plant domestication through horticulture at the end of the period. The Hopewell culture (200 BCE–500 CE) appeared in the middle of the Woodland period. Trade and organized ceremonialism increased, evidence of which can be seen today in the culture's elaborate earthworks.

Mississippian culture (800–1700 CE) supplanted Woodland. The former arrived slowly—characterized by a more sedentary lifestyle. After 1000 CE, Mississippian culture developed in a few locations in Minnesota, as did the cultivation of maize and beans.

Earthworks were the acme of Mississippian culture, but they were not as grandly engineered in the St. Croix Valley. Across the Mississippi River from modern-day St. Louis, Cahokia represented the cultural zenith. Charles C. Mann, in *1491: New Revelations of the Americas before Columbus*, wrote:

> *Anyone who traveled up the Mississippi in 1100 A.D. would have seen it looming in the distance: a four-level earthen mound bigger than the Great Pyramid of Giza. Around it like echoes were as many as 120 smaller mounds, some topped by tall wooden palisades, which were in turn ringed by a network of irrigation and transportation canals.*

The St. Croix Valley earthworks, also impressive engineering feats, exist in familiar places. Fairview Cemetery has a six-and-a-half-acre and 820- by 350-foot-wide mound. Painted Rock displays ancient Siouan sandstone pictographs 30 feet above the St. Croix River. W.H. Winchell's *The Aborigines in Minnesota* (1911), based on Jacob Brower's archaeological discoveries, catalogued "Rattlesnake Mound" in Afton: six circular and one elongated mound. There were mounds in Lakeland, nine mounds below Arcola and one elongated and twenty-six circular mounds in Vasa (present-day Copas). But sadly, the mounds were excavated without concern for the remains.

Winchell ranted, "Of all the Indian stocks, probably the Dakota Indian…has produced fewer men pre-eminent for noble characteristics and more instances of pre-eminence for the ignoble traits of character, than any stock whose history is known." Contemporary ethnocentrism

prevailed for decades. In *Washington: A History of the County* (1977), editor Willard Rosenfelt demeaned "The idea that the Mound Builders were of the same race as the Indians seems to be gaining ground." He acknowledged that the American Indian civilization that Europeans first encountered was compromised, as historic revisionism took hold. He further maligned, "The history of Minnesota's Indians is but a page in the world-wide story of the conquest of simple peoples and their homelands by the civilization, arms, and diseases of a more dominant race."

American Indian societies were transformed by epidemic diseases and warfare. European colonization pushed traditional territories west. In *Creating Minnesota* (2007), Annette Atkins elucidated on the legacy of epidemic diseases:

> *Europeans introduced at first unwittingly and later knowingly devastated the native population by as much as 90 percent. And the Indians' lack of immunity to European diseases dramatically lessened their ability to resist white invasion. The earliest germs were introduced not at Plymouth Rock or even Jamestown but probably at Newfoundland or elsewhere along the Canadian and New England coasts, when European fishermen went ashore to dry their catch.*

Fur traders influenced the American Indians; however, as McMahon and Karamanski wrote, "It was the interests and actions of the Indians, not those of a handful of fur traders or Indian agents, that shaped the early history of the valley."

Despite preferring the name "Dakota" (translated roughly as "friends" or "allies"), the U.S. government used "Sioux," a corruption of "Nadouessioux" (from the Ojibwe word "Nadowa," meaning "snake" or "enemy"). Besides the Dakota in the St. Croix Valley, there were also the Mdewakanton, Sisseton, Wahpeton and Wahpekute among the tribes of the seven council fires. European settlement moved the Ojibwe into the Dakota's territory in the 1700s and then pushed the eastern Dakota. By 1750, the Ojibwe controlled northern Minnesota, and territorial encroachment continued when the St. Croix River Valley was settled. McMahon and Karamanski summarized, "The Dakota's ability as warriors, their generosity and their pride as a nation were all defining characteristics of the first inhabitants of the St. Croix Valley." The authors continued, "The Dakota could afford to be generous because they occupied one of the largest and richest regions of the North American interior."

The Ojibwe were the second major tribe in the St. Croix Valley. Another corruption—Chippewa—was commonly used on treaties and geographic names. Anishinaabe ("original man" or "spontaneous or genuine people") is the tribe's name for themselves and several related indigenous groups. Ojibwe, an Algonquian language, includes Ottawa, Cree and Miami. Despite later conflicts, the intertribal relations were initially peaceful. McMahon and Karamanski elaborated, "The Ojibwe originally entered the river and lake country of the Wisconsin border as Dakota guests, not invaders."

The Ojibwe and fur traders' overhunting caused the decline of game in the valley. The Dakotas' once-diverse diet relied on the western buffalo hunt. In the conflict with the Dakotas, another asset was French firearms. Each successive administrator—the French, the British and finally the Americans—oversaw fur trading with less rigor. The natural balance was tilted toward the ultimate calamity—accepting treaties. Eventually, without options, the Ojibwe and Dakota signed unfair treaties that set the stage for removal.

The Ho-Chunk (Winnebago) was the third tribal group. Largely forcibly relocated to reservations from Wisconsin, the Ho-Chunk also spoke a Siouan language and resettled in Minnesota from 1847 to 1862. After the Dakota Conflict (1862), the treaty was abrogated; they were exiled to Wisconsin and Nebraska reservations.

After relocation, the misery of the American Indians continued. Through treaties, land was stolen for miniscule money, food, alcohol and trinkets. Atkins described the travesty:

> *When I look over the shoulders of the Dakota, Anishinaabe, and others native to this place, I see a world starkly different from my own. I see loss and hurt too painful to look at for long. I see the rage that comes from a dream desired, a way of life mangled, faces scarred by smallpox, land taken. I see alienation, languages wrenched away, honored images defiled. I see, too, resignation and demoralization, the despair that comes from having lost so much.*

EUROPEAN EXPLORERS AND TREATIES

The French first explored the St. Croix River Valley in the seventeenth century. Later, the British and Americans harvested the abundant natural resources. After the Louisiana Purchase (1803), adventurers catalogued

the area. According to University of Minnesota president William Watts Folwell, in *A History of Minnesota, Volume I*, "The St. Croix forms part of an old canoe route from the Mississippi to the head of Lake Superior. Du Luth came down it in 1680; Schoolcraft went up it in 1832. Without a doubt many white men had, between these dates, navigated this beautiful stream."

Daniel Greysolon, Sieur du Luth (or Duluth), was the first European on the St. Croix River. In 1679, he traversed Dakota lands and the future site of Stillwater. A year later, Duluth, "with four Frenchmen and two Indian guides, ascended the Bois Brulé River, portaged over to the head of the St. Croix, and followed that down to Point Douglass [*sic*], where he doubtless recognized the great river," said Folwell in *The North Star State* (1908). Louise Phelps Kellogg, in *The French Regime in Wisconsin and the Northwest* (1925), wrote:

> *Duluth now determined to explore a water route to the Sioux country, and thence to push westward toward the salt water he had heard of from his men. He therefore ascended the Brule River of Wisconsin, cutting down en route a hundred or more beaver dams; then portaged to the St. Croix, and by July had run down that stream to its mouth.*

Later, he rescued Father Louis Hennepin from the Dakota Indians on July 25, 1680. Hennepin had "discovered" the Falls of St. Anthony while captive under the command of Michel Accault and accompanied Antoine Anguelle on a mission for René-Robert Cavelier, Sieur De La Salle.

On his second voyage (1683), Duluth recognized the strategic importance of the St. Croix. He found an accurate mapmaker to record his findings. In *Concise History of Minnesota*, Neill said about Duluth, "It is probable that he established the post at the sources of the St. Croix River, which, as early as 1688, is marked Fort St. Croix, upon one of Franquelin's Maps."

Father Louis Hennepin (1640–circa 1701) briefly crisscrossed the St. Croix Valley. His factually misleading recollections gained worldwide notoriety in *Description of Louisiana* (1683). Hennepin wanted to sell books, and he did: the international bestseller read like an adventure. For the first time, he described the St. Croix—here, the River of the Grave, or *Riviere du Tombeau*,

> *Forty leagues farther on there is river full of rapids. By following it and keeping to the northwest* [the footnotes posited that he meant northeast], *one can reach Lake Superior by portaging to the Nimissakouat River, which empties into that lake. The former is called the River of the Grave because the Issati left near it the body of one of their warriors who*

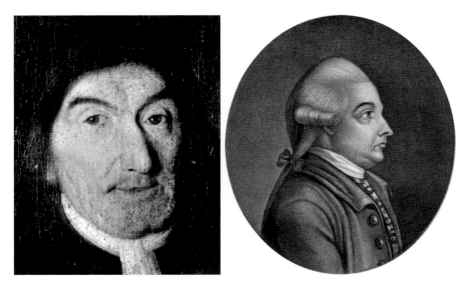

Left: Father Louis Hennepin called the St. Croix River *Riviere du Tombeau*, or the "River of the Grave." *The Minneapolis Collection.*

Right: Jonathan Carver was one of many famous explorers who traveled through the St. Croix Valley. *The Minneapolis Collection.*

had died from a rattlesnake bite. In accordance with the Indian custom I put a blanket on the body. This act of humanity brought me the attention of the dead man's tribe and aroused their gratitude. They had me attend a feast given in my honor in their country, to which more than a hundred Indians were invited

Though Hennepin named the river after the dead man, "on contemporary Italian, French, and Dutch maps, for example, the stream was invariably labeled Riviére de la Madeleine or Magdeleine," wrote James Taylor Dunn in *The St. Croix*. But another explorer provided the present name. Louis XIV, "The Sun King," appointed Nicolas Perrot to claim possession. He constructed Fort St. Antoine (1688) on the east bank of Lake Pepin, two miles below present-day Stockholm, Wisconsin.

The origin of the name St. Croix is debated. Neill related a persistent and well-established theory on the river's name: a voyageur died there. Warner, Foote and A.B. Easton echoed his opinion. Two additional versions exist: a dalles rock formation near Taylors Falls and the desire of missionaries for another geographic saint's name—for example, the St. Peter (later Minnesota) River, St. Paul and St. Anthony.

Jonathan Carver (1710–1780) also visited the St. Croix Valley. He traveled from Boston to the old Northwest but, unlike other explorers, his writing was empathetic to American Indian culture. Neill described his adventure: "Near the St. Croix river he met some of the eastern Sioux, whose bands he mentions, as the Nehogatawonahs, Mawtawbauntowahs and Shashweentowahs." In *Jonathan Carver's Travels through America: 1766–1768*, he wrote evocatively about the St. Croix and Mississippi River Delta. In over thirty editions and printed in multiple languages, the book was the polar opposite of Zebulon M. Pike's.

Published in three voluminous editions, Pike's (1779–1813) journals were wordily titled *The Expeditions of Zebulon Montgomery Pike to the Headwaters of the Mississippi River, Through Louisiana Territory, and New Spain, during the Years 1805-6-7*. In 1805, Pike purchased two parcels of land from the Dakota and Ojibwe. In *Indians in Minnesota*, Kathy Davis Graves and Elizabeth Ebbot assessed the Dakota treaty signed on September 23, 1805: "In 1805, Captain Zebulon Pike signed a treaty with the Dakota (Mdewakanton Band) that ceded a nine-square-mile tract of land for a fort and trading post at the confluence of the Minnesota and Mississippi rivers. Some sixty gallons of liquor and $200 worth of gifts were used to encourage the sale." The U.S. Senate approved the treaty on April 16, 1808. The 100,000 acres were estimated at $200,000 by Pike, but the U.S. Senate appraised the land at $2,000. Settlement remained illegal in the St. Croix Valley when Fort Snelling was established in 1819.

In 1832, Henry Rowe Schoolcraft (1793–1864) searched for the headwaters of the Mississippi River. The Office of Indian Affairs authorized the expedition on May 3, 1832, and Boutwell accompanied the geographer, ethnographer and geologist. Lieutenant James Allen, the leader of the military in Schoolcraft's *Expedition to Lake Itasca*, said on July 27, 1832:

> *The Lake St. Croix continued twenty-one miles beyond our encampment, making its whole length thirty-six miles, in a north and south direction. It is clear and deep, and seldom more than three or four miles in breadth. The country on each side is the same as the prairie that borders the Mississippi. The lake gradually contracts at its upper end, to the breadth of the river.*

The expedition physician, Dr. Douglass Houghton, described the scenic grandeur on July 26, 1832:

We entered Lake St. Croix which commences almost immediately from the Mississippi & ascended the lake 20 miles in a northerly direction where we encamped for the night. Lk. St. Croix is a beautiful sheet of water, through which the waters of the St. Croix enter the Mississippi. It is thirty six miles in length and has an average breadth of 1½ miles. The shore is mostly composed of bluffs of calciferous sandstone which rise quite abruptly to a height of from 150 to 200 feet. The country above is mostly prairie & oak opening & is beautiful beyond description.

Neill related Boutwell's naming of Lake Itasca:

Mr. Schoolcraft, who was not a Latin scholar, asked the chaplain for a Latin word which signified truth, and was told veritas, and the word for source, and caput was mentioned. Schoolcraft was fond of coining words, and by striking out the first syllable of veritas, and the last of caput, he made the word Itasca.

In 1838–39, the French-born cartographer Joseph N. Nicollet (1786–1843), also accompanied by Boutwell, promoted the St. Croix and Mississippi

Explorer Joseph Nicollet recognized the economic potential of the St. Croix River. *The Minneapolis Collection.*

River Delta's waterpower possibilities with his map "The Hydrological Basin of the Upper Mississippi." Nicollet assessed the St. Croix River near St. Croix Falls: "The river beyond the lake is almost as wide as the lake itself but it loses the characteristics of a lake because of its shallowness and the presence in it of numerous islands which divide it into channels." Nicollet camped at St. Croix Falls.

The fur trade declined as *Pinus strobus* ascended. William Lass stated in *Minnesota: A History,* "Because of the immense stands of white pine on its upper reaches, the St. Croix Valley was one of the first areas claimed when the land was legally opened to settlement." But, for this to occur, the American Indians needed to be removed. Ojibwe and Dakota warfare hastened the tragic end. Treaties expropriated land. Neill said in *Concise History of the State of Minnesota*:

> *The year 1837 is an important one in the history of Minnesota.... Governor Dodge, of Wisconsin Territory, as United States commissioner, on the twenty-ninth of July, concluded a treaty with the Ojibways, by which they agreed to cede all the lands north of a line running from junction of the Crow Wing and Mississippi rivers, to the north point of Lake St. Croix. The same year a deputation of Dakotahs proceeded to Washington, and in the month of September ceded all their lands east of the Mississippi.*

The Ojibwe and Dakota were without recourse. McMahon and Karamanski wrote, "The dependency of both the Dakota and the Ojibwe on European Americans for alcohol, trade goods, and, increasingly, food was the knife's point used to push them into treaty negotiations." At St. Peters on July 29, 1837, the Ojibwe treaty was signed, and the tribe received $9,500 in cash, $19,000 in goods, $3,000 for blacksmith shops, $1,000 for farm implements, $2,000 in provisions and $500 in tobacco, with a few other provisions added. The Dakota treaty followed on September 27, 1837, and the Ho-chunk on November 1, 1837. "Hardly was the ink dry on the St. Croix treaty when men with an interest in lumber came to the St. Croix River," wrote Agnes M. Larson in *The White Pine Industry*. The white farmers arrived en masse and were "barely tolerated" by the Dakota. "Tragically, throughout the painful twilight of Indian tenure, while English and Swedish voices replaced those of the Ojibwe and Dakota along the St. Croix, the vicious intertribal war continued," said McMahon and Karamanski.

BATTLE HOLLOW

The Dakota attacked the Ojibwe at Battle Hollow on July 3, 1839. Ongoing conflicts and treaties dispossessed the American Indians of the St. Croix Valley. Fleetingly, historians fumbled for the ur-cause of Battle Hollow. Neill, in *History of Minnesota*, described an "unprovoked attack of Hole-in-the-Day, beyond Lake qui Parle, some Dahkotas met an Ojibway, near the grave-yard, at Fort Snelling, and killed him."

At the fort guardhouse, the imprisoned murderers were released. Revenge was sought. Then, hundreds of Ojibwe arrived at Fort Snelling for promised federal government annuities in June 1839. On July 2, the "Son-in-law of the chief of the Sioux band, at Lake Calhoun, named Meekaw or Badger, was killed and scalped by two Chippeway of the Pillager band," said Neill and Warner in *History of Hennepin County and the City of Minneapolis* (1881). A Dakota war party followed in the opening prelude to Battle Hollow:

> *The Kaposia band of Sioux pursued the Saint Croix Chippeway, and on the third of July found them in the Penitentiary ravine at Stillwater, under the influence of whisky. Aitkin, the old trader, was with them. The sight of the Sioux tended to make them sober, but in the fight twenty-one were killed and twenty-nine were wounded.*

The Ojibwe were taken by surprise. Neill wrote in *History of Minnesota*, "At daybreak, the first intelligence of the presence of the Dahkotahs was a volley of musket balls poured from the bluffs into the midst of the Ojibway camp."

The number of casualties in accounts varied, but in all versions, the Dakota are always the victors. The conflict's roots are more complex than historians admit. McMahon and Karamanski wrote, "Like all wars difficult to bring to a conclusion, the conflict continued not merely because of blood feud and misunderstanding, but because the Ojibwe and the Dakota were locked in a territorial struggle closely linked to each side's survival as people."

Soon, the path of history turned. The American Indians were forcibly moved west. A flood of men from the east arrived. Boosters and investors surveyed the land. William H.C. Folsom said in *Fifty Years in the Northwest* (1888):

> *In the year 1838, being the year succeeding the purchase of the lands bordering on the St. Croix river and a portion of her tributaries, may be dated the commencement of the settlement of the St. Croix valley; but with*

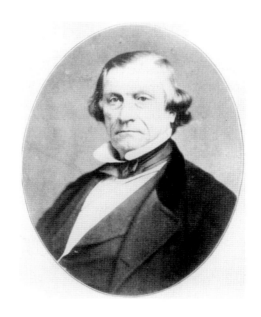

Joseph Brown founded Dacotah, just north of Stillwater in 1839. *The Minneapolis Collection.*

the exception of the Hon. Joseph R. Brown...[they] came here for the purpose of lumbering, and in no instance as permanent settlers.

JOSEPH BROWN AND DACOTAH

Stillwater originated with Joseph Renshaw Brown (1805–1870). At fourteen, the Maryland native ran away from a printing apprenticeship in Lancaster, Pennsylvania. He enlisted as the drummer boy at Fort Snelling in 1819. After his service concluded in 1825, he joined the American Fur Company.

Hedging his bets on a future regional metropolis, he resided in various frontier settlements, each strategically located on rivers. First, he lived four miles upstream, near St. Croix Falls, at Granite Rock. Congress had outlawed alcohol in Indian trade in 1832. Nonetheless, Brown illicitly smuggled the lucrative contraband, to the dismay of Schoolcraft, who "revoked his license" to trade at Granite Rock. Brown relocated to Oliver's Grove, near present-day Hastings in 1833. Later, he settled on Grey Cloud Island—across from the future failed metropolis of Nininger—and on the Mississippi River south of St. Paul Park.

Dacotah was established in 1839 as a fur traders' stopover. Brown served three terms in the Wisconsin Territorial legislature before abandoning it for Grey Cloud Island in 1843. Emma Glaser enumerated his myriad

professions in *Minnesota History* (1943): "trader, pioneer farmer, lumberman, legislator, public officer, editor, politician, Indian agent, investor, and speculator." Moreover, he briefly owned the *St. Paul Pioneer* newspaper; founded Henderson, Minnesota; and suggested Minnesota's spelling.

By 1846, Dacotah was a ghost town.

PIONEERS AT TAMARACK HOUSE (1839)

When Joseph Brown of Crawford County authored legislation that created St. Croix County on November 20, 1841, Dacotah was the county seat. Brown served on the Crawford County board and as a ferryboat driver at the "Battle Ground" (head of Lake St. Croix). The land was eventually annexed as the Carli and Schulenburg addition, the first of twenty additions to Stillwater.

Brown's half sister and husband were the first settlers. Dacotah was near present-day Minnesota Highway 95 and the Joseph Brown Trail. In *Joseph R. Brown, Adventurer on the Minnesota Frontier: 1820–1849*, Nancy Goodman and Robert Goodman described the scene: "There was yet no residence at Dacotah to receive the Carlis, only the shell of an ambitious framed building destined to serve as hotel, courthouse and county offices and behind it a small building of stone for the jail."

Lydia Ann Carli landed at Grey Cloud Island on May 13, 1841, and went on to become the first European American woman in the present-day city limits of Stillwater. She was born in Lancaster, Pennsylvania. She married Paul, an Italian-born painter and musician, and after they lost a claim in Chicago, they relocated to Tamarack House. Paul Carli constructed a two-story house at Bolles Creek, near Afton, in 1844. Tragically, Paul drowned in 1846. His younger brother, Dr. Christopher Carli (1811–1887), educated at the University of Heidelburg, was the only doctor for one hundred miles. After a year of mourning, Lydia married Christopher.

Jacob Fisher and Sylvester Stateler—the millwright and blacksmith, respectively, for the St. Croix Lumber Company—constructed Lydia Carli's living quarters in Dacotah. As an octogenarian, Carli reflected in the *Gazette* of September 6, 1899: "[Fisher] had been employed as a sort of boss carpenter at St. Croix Falls, and a blacksmith named Stateler, came down here, and…went prowling round in the vicinity of McKusick lake and Brown's Creek until he evolved from his fertile brain a plan for

utilizing the water for running a saw mill and enlisted John McKusick in the scheme."

Lydia Carli commands a special place in Stillwater's history. She related a comical anecdote in the *Gazette*:

> *She referred to a historical work in which she was represented as having been married in 1839, while dates of the births of her first two children were given as 1835 and 1838 respectively. When she read this she was so indignant and exasperated that she seriously considered the question of employing an agent to go and assassinate the author, but finally decided on a milder form of revenge, and next time she met the writer of the work she contented herself by asking him if he wasn't ashamed of himself.*

And then, she concluded that "he was, [and] she forgave him."

Joseph Hurlburt preached the first sermon at Tamarack House. A few weeks later, Boutwell and Reverend Henry Brace held services. The first Swedish settler in Minnesota, Jacob Folstrom, converted to Methodism in 1840. Then, as a missionary, he said prayers for a good meal at Tamarack House.

Reverend William Thurston Boutwell (1803–1890) lived for sixteen years, and preached for forty-three years, in the St. Croix Valley. Educated at Dartmouth (1828) and Andover Theological Seminary (1831), he ministered at Leech Lake, the first mission west of Duluth.

Boutwell married Hester Crooks on October 11, 1834. Near Stillwater, he purchased a 160-acre claim from W.R. Vail in June 1847 and, with his wife, two sons and a daughter, lived alongside the American Indians. The daughter of a fur-trading Indian chieftain employed by John Jacob Astor, Hester was born on Drummond Island (Lake Huron) and educated at Mackinaw Mission and in France. She was fluent in French, English and Ojibwe. Crooks exemplified Métis culture during fur trading. As McMahon and Karamanski said:

> *The product of the fur trade marriages, the Métis, or mixed-blood offspring, significantly influenced Ojibwe society. The Métis were a significant portion of the population of the Upper Midwest. By 1820 there may have been as many as ten thousand Métis south and west of the Great Lakes.*

Hester died in 1853. Boutwell married Mary Ann Bergen of New Hampshire on September 26, 1854; she perished in 1868. After suffering an intestinal rupture, Boutwell later died at eighty-seven.

In 1844, Captain Stephen B. Hanks arrived in the nascent lumber town of Dacotah. The ninety-four-year-old Hanks told Lucy Leavenworth Wilder Morris in *Old Rail Fence Corners*:

> *We built a boom just where Stillwater is today, in still water. Joe Brown had a little house about a mile from there. There were the logs, and the mill at St. Croix was useless. McCusick [sic] made a canal from a lake in back and built a mill. The lumbermen came and soon there was a straggling little village. I moved there myself one of the first.*

Hanks's career began in 1841. Born in Albany, Illinois—a city that provided several riverboat captains and crews for Stillwater—the cousin of Abraham Lincoln rafted the first logs on the *Amulet* in 1846. Agnes Larson, in a *Minnesota History* article, said Hanks "saw both the coming and the going of a great industry in the valley of the St. Croix during his lifetime."

Boosters and travelers arrived, touting the scenic beauty and economic potential of Stillwater. They stood to profit from the development of the old Northwest, the Mississippi and St. Croix Delta. In 1853, John Wesley Bond promoted Stillwater's lumbering reputation: "Stillwater is the headquarters of the outfit and lumbering done above it, on the St. Croix, and has more substantial, reliable business, for the extent of it, and more capital, and less pecuniary embarrassment, than any other town in Minnesota." In 1845, Nathaniel Fish Moore wrote in *A Trip from New York to the Falls of St. Anthony* an account of the then-hyphenated fledgling city: "At Still-water the little settlement of two years growth consists of a saw mill, a tavern, a country merchant's store, and some half dozen wooden houses beside." Oddly effusive, he continued, "I looked for something wild and savage; for close-entangled and impervious forests, such as one sees on the sides of the Alleghany or of the Green Mountains; but the scenery resembles more that of a finished English park."

PUTTING STILLWATER
ON THE MAP

When I came to Stillwater back in 1848, I thought I had got to the end of the line. I came up on the Sentinel with Captain Steve Hanks. He was captain of a raft boat then. It took ten days to come from Albany, Illinois. There was nothing to parade over in those days. We took it as it come and had happy lives. Stillwater was a tiny, struggling village under the bluffs—just one street. A little later a few people built in the bluffs and we would climb up the paths holding onto the hazelbrush to help us up. Stillwater was headquarters for Minnesota lumbering then. We would all gather together and in about two minutes would be having a good time—playing cards or dancing.
—*Mrs. Mahlon Black, the wife of a mayor of Stillwater, in Lucy Morris,* Old Rail Fence Corners

Formerly, we had our doubts as to the great extent of our pineries. Now, we have no doubt…so that centuries, will hardly exhaust the pineries above us.
—*James M. Goodhue,* Minnesota Pioneer, *April 15, 1852*

The lumber industry sparked Stillwater's rapid development. The "North Woods'" pines covered thirty-eight million acres and 70 percent of the land in the state. In the St. Croix Valley, Stillwater had the third lumber mill. The lumber industry relentlessly expanded during the steamboat era, attracting immigrants and supplying logs for the burgeoning Midwest.

Before Stillwater, there were mills. Augusts B. Easton reported, "As early as 1836, a Mr. Pitt went with a boat and a party of men to the Falls of Saint

Croix to cut pine timber, with the consent of the Chippeways but the dissent of the United States authorities." In the winter of 1836–1837, Captain Edward W. Durant recalled Joseph R. Brown cutting logs in a private treaty with the Ojibwe near Taylors Falls. The first lumbermen were fur-trading Democrats: Lyman Warren, William Aitken and Sibley, with the Ojibwe Indians north of Stillwater until the tribe ceded land in 1837.

Marine Mills was the second mill in Minnesota after the Fort Snelling government mill (located at present-day Minneapolis). At Judd's tavern in Madison, Illinois, news of the Dakota and Ojibwe treaties was received in late 1837. Hiram Berkey of Marine Lumber Company purchased the first property, with partner George B. Judd. Lewis S. Judd and David Hone also staked a claim. Orange Walker arrived in the winter of 1838, before the 1839 survey. Neill, in *Concise History of the State of Minnesota*, said, "Before the treaties were duly ratified, the wilderness was visited by white men seeking…valuable pine forests."

"Early in August Franklin Steele, Dr. Fitch, Jeremiah Russell and a Mr. Maginnis reached the Falls of St. Croix in a birch bark canoe, and began to erect a claim cabin." They traveled on the *Palmyra* while building a sawmill at St. Croix Falls in the spring of 1838. In the winter of 1838, millwright

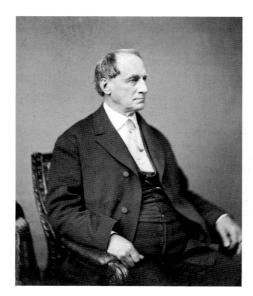

Levi Stratton, Jeremiah Russell and Robert McMasters worked for Franklin Steele—and jumped Judd's claim. The partners paid Steele $300 in May 1839. Orange Walker led the Marine Lumber Company and milled the first lumber on August 24, 1839, which continued into the late 1880s.

In the 1840s, sawmills clustered along the St. Croix Valley. At St. Croix Falls in 1840 was William S. Hungerford, Livingston & Company. Other St. Croix Valley lumber mills included the following, with ownerships and conjectured dates: in Bolles Creek (Afton), Lemuel Bolles at Lowry and Company (1854); in Afton, Thomas & Sons (1855, closed

Boston speculator Caleb Cushing's legal wranglings prevented the development of St. Croix Falls. *The Minneapolis Collection.*

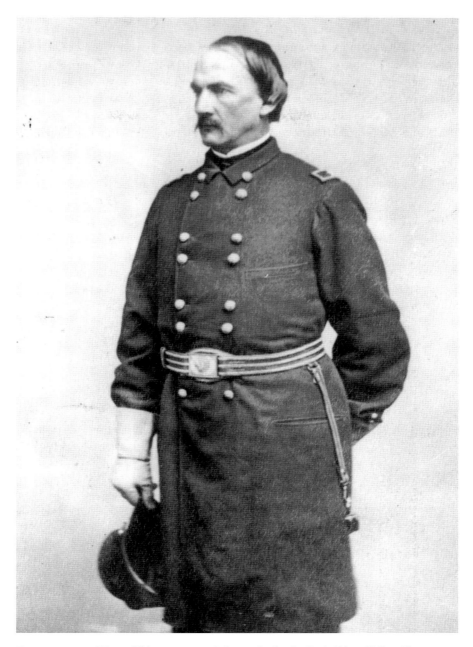

Future governor Henry Sibley was an early logger in the St. Croix River Valley. *The Minneapolis Collection.*

after the Panic of 1857), and Getchell Brothers (1861); and in Arcola, Martin Mower, David B. Loomis, W.H.C. Folsom and Joseph Brewster (circa 1846–1847). In villages like Franconia, mills also existed, such as those of the Clark brothers and Ansel Smith (circa 1852–1854). In Lakeland, Moses Perrin started a mill in 1852 that Freeman C. Tyler completed; in South Stillwater, Socrates Nelson and David Loomis built a mill in 1852.

McKUSICK'S SAWMILL

Stillwater developed around William McKusick's sawmill (1843). The founder met Calvin Leach of Vermont, Elam Greeley of Maine, Elias McKean of Pennsylvania and millwright and engineer Jacob Fisher; they had worked for Franklin Steele and ever-changing partners at St. Croix Falls Lumber Company. Greeley and Fisher rafted logs while McKean and Leach traveled to St. Louis and met with McKusick. "Financial embarrassment, and at last insolvency, interrupted operations at St. Croix Falls," said Warner and Foote.

Jacob Fisher was sent by St. Louis lumber concerns to develop St. Croix Falls and failed. He claimed property at the head of Lake St. Croix in 1843. Glaser related his engineering insights: "He began to co-ordinate the facts at hand. Here was the source of a stream at a reasonable distance from an ideal river, at a promising height, but with a too gradual drop. Could it be directed on a steeper course than it now followed and give water power at its entrance to the river to turn a mill wheel? Why not? The idea flashed and grew." Moreover, she wrote, "The plan appeared feasible and inexpensive." Fisher harnessed the power of the shallow forty-six acres of Lake McKusick. The partners purchased the claim from Fisher.

John McKusick (1815–1900) was a Maineite—tall and gaunt, "like Lincoln," for whom he campaigned in 1860. McKusick gradually bought out his three partners. And his interests extended beyond business: he served as state senator from 1863 to 1866.

In 1844, the Stillwater Lumber Company was organized. The first frame building (forty by sixty-five feet) was the mill, with a thirty-six-foot-diameter waterwheel. The mill was torn down in 1871 and replaced by a gristmill in 1901.

Without a boom, the lumber industry was incomplete. In "When Logs and Lumber Ruled Stillwater," Agnes M. Larson wrote, "The boom was a busy mart which was to the lumberman what the exchange was to the

merchant of a big city." The St. Croix Boom Company was organized by McKusick, Socrates Nelson and Levi Churchill of Stillwater; William H.C. Folsom of Taylors Falls; Orange Walker and George B. Judd of Marine Mills; and Daniel Mears and William Kent of Osceola, Wisconsin, on February 7, 1851.

Located two miles north of Osceola and six miles south of Taylors Falls, the boom was chartered for $10,000. Folsom complained that it was "too narrow for the annually increasing production of logs." By 1856, the boom had a new charter, reincorporated by Martin Mower, Folsom, Isaac Staples, Christopher Carli and Samuel Burkleo.

STILLWATER

Stillwater's scenic beauty was lauded by visitors—even as the city increasingly became an industrial logging town. Sir Edward Sullivan in *Rambles and Scrambles in North and South America* said, "Proceeding onwards we crossed the boundary between the Chippeway and Sioux country, and arrived at 'Still-Water,' a small settlement created and supported entirely by the lumbering trade." In *Summer Rambles in the West*, Elizabeth F. Ellet added, "The prospects of the town are flourishing, and its advantages of location and the natural resources of the country must soon make it a place of importance and wealth."

Settlers also painted a picture of an isolated village. William H.C. Folsom arrived in Stillwater in 1845:

> *We landed just in front of the store of Nelson & Co. Just below the landing was a clear, cold spring, bubbling out of the earth, or the rock rather. It was walled in and pretty well filled with speckled trout. On the opposite side of the street Walter R. Vail had a house and store; north of Vail's store the house and store of Socrates Nelson. Up Main Street, west side, stood Anson Northrup's hotel & Greely [sic] and Blake's post office and store.*

He also said John McKusick's mill was located on "the shore of the lake, north of Chestnut Street."

Harvey Wilson surveyed Stillwater in Wisconsin Territory on September 12, 1848. Few of the plat's streets were completed for thirty or forty years because of the hilly terrain. In *Stillwater Historic Contexts*, by Robert C. Vogel, the principal investigator said:

Recognizing the importance of the St. Croix waterway, the initial developers of Stillwater oriented the orthogonal plat to Lake St. Croix, which placed the commercial district along streets running parallel to the lakeshore, on an axis of approximately north-north-west to south-southeast. Later nineteenth and twentieth century additions were laid out in conformance to the standard longitudinal and latitudinal grid of the rectangular survey and emphasized residential development and parallel streets.

The Glaser article said, "The town gained a real impetus in 1848, when there was a flood of immigration. New buildings went up in a hurry. Streets were improved. The quagmire of Main Street was rudely covered with mill slabs." Downtown, with an elevation twelve feet lower than today, flooded almost annually; the town was nearly inaccessible following the 1850 flood. Folsom described boats landing on shore at the Minnesota House (on the southwest corner of Chestnut and Main Streets).

On May 14, 1852, torrential rains transformed Stillwater. McKusick's storage lake overflowed, which Easton coined "The Great Landslide." As Folsom reported:

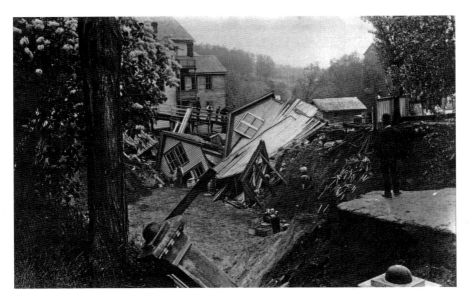

Persistent flooding hastened Stillwater's development—for example, at Fourth and Hickory Streets in 1894. *The St. Croix Collection.*

During a terrible storm, the dam at the new outlet gave way and a tremendous body of water, carrying with it the debris of dikes and dams, rushed tumultuously down the ravine, covering the low shores of the lake beneath, and depositing a new geological stratum of drift over a surface of at least six acres to an average depth of about ten feet.

Unbelievably, the property was improved. A steamboat landing was created and eight to ten acres pushed through the Mulberry Street ravine on Lake St Croix.

Before the Great Landslide, Stillwater became the Washington county seat in 1849. As Daniel J. Boorstin wrote in *The Americans: The National Experience*, "The 'county seat' (an Americanism, first recorded in 1803), the headquarters of each county, was where the administrative offices, the county court, the county jail, and the county records would all be located." St. Paul and Stillwater were incorporated on March 4, 1854. Appropriately, John McKusick was elected the first mayor. Mayors originally held annual terms (1854–80), as did those in St. Anthony, St. Cloud and many Minnesota municipalities at the time. In Stillwater, terms were extended to two years (1881–1915); finally, in 1915, mayoral terms became four years.

THE STILLWATER CONVENTION

The Stillwater Convention was a reaction to political events in the St. Croix Valley. Wisconsin received statehood, and the western portion of the St. Croix Valley was excised. Or was it? The thirtieth state in the Union grappled with fundamental questions as Henry M. Rice and Henry Sibley initiated their political careers. In the *Minnesota History* article "The Birth of Minnesota," Lass said, "It is an odd and perhaps little-known fact of history that the election that launched the careers of Minnesota's two most famous frontier politicians was held in Wisconsin Territory."

The St. Croix River Valley was politically divided—on the map and in governance—affecting the course of the future. According to McMahon and Karamanski,

The division of the St. Croix Valley had an initially depressing effect on its economy. Residents on both sides of the St. Croix River regretted their separation for years to come. Wisconsinites, with their North Woods

identity, longed to be part of the new territory. Minnesotans, in turn, pitied their poor Wisconsin cousins for being so close to them but captive to another state.

The Wisconsin Constitutional Convention seconded the bisection of the St. Croix River Valley. Before statehood, political camps espoused potential Minnesota boundaries. Morgan Martin pushed for the Northwest Ordinance border of the Mississippi River as the western boundary of Wisconsin, which was dismissed as ungovernably too large. Senator Stephen A. Douglas (Illinois) proposed carving proportionally sized states of the old Northwest. At Wisconsin's first Constitutional Convention, William Holcombe, St. Croix County's only delegate, suggested organizing a new state, with Stillwater as the capital.

Over the years, Stillwater was within numerous territories. Joseph Brown and St. Paulites lobbied for the St. Croix River as the state border. In the Wisconsin legislature, Brown was elected from Crawford County before the creation of St. Croix County by the state's legislature in 1840. Crawford County was included in Michigan Territory until 1840 and extended to the Mississippi River. The St. Croix Valley was, at times, in Michigan Territory (1819–36), Illinois Territory (1809) and Indiana Territory (1800). As Agnes M. Larson noted in her article "When Logs Ruled Stillwater," the area was originally claimed by Virginia in its "sea-to-sea charter."

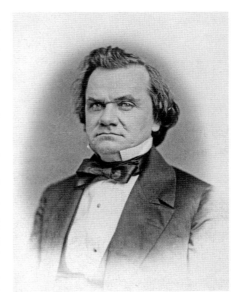

After Wisconsin became a state, lawyer Colonel Charles E. Flandrau said in *The History of Minnesota and Tales of the Frontier* (1900), "In 1848, there had sprung into existence in that state, west of the St. Croix, the towns of Stillwater, St. Anthony, St. Paul, Marine, Arcola, and other lesser settlements, which were all left in Minnesota when Wisconsin adopted the St. Croix as its

Stephen Douglas and Democratic politics were fundamental in the creation of the state of Minnesota. *Wikimedia Commons.*

western boundary." Politically severed, Stillwater competed for capital investment and settlers: the convention was the solution.

The convention organized a territory for the western portion of the St. Croix Valley—then politically afloat. The conventioneers were "Yankee Lumbermen," "Fur traders" and "Frontier boosters," according to Lass in *Minnesota: A History*. Fur traders desired a tall state (north–south oriented), while farmers wanted a wide state (east–west oriented) that extended to the Missouri River. A convention was called by eighteen men on August 4, 1848. On August 26, the delegates included Sibley, Brown, Rondo, Guerin, Godfrey and Orange Walker. Mary Lethert Wingerd in *North Country: The Making of Minnesota* said, "The sixty-one self-appointed 'delegates' were composed almost entirely of Anglo merchants, traders, sawmillers, and lumbermen, with a few lawyers thrown in for good measure." The timing of the convention was advantageous to the delegates. Wingerd continued:

> *Federal surveyors had recently completed a partial survey of lands west of the St. Croix and the first public sale was scheduled to take place at St. Croix Falls on August 28, two days after the Stillwater Convention. Brown had proposed the convention date supposedly to make* [it] *convenient for those attending the land sales. It was a masterful move. The upcoming sale certainly added a sense of urgency to the Stillwater proceedings, a reminder that they all were technically squatters until they acquired legal deeds to their claims.*

Joseph R. Brown led the convention. With political acumen, "Brown whipped out an already-prepared petition to the president, requesting the formation of a new territory for the disenfranchised Minnesotans," said Wingerd. He represented fur traders' interests and suggested the name Minnesota.

The convention took an odd turn. According to Lass's article "The Birth of Minnesota," some conventioneers were convinced after statehood that Stillwater was still in Wisconsin Territory "existing in residual form after the State of Wisconsin had been admitted to the union in May." Before Minnesota Territory was organized, John Catlin acted as territorial governor. He claimed the governorship of Wisconsin Territory—the portion of the territory excluded from the state. Stillwater was a no-man's land, a "Benign Fiction," Folwell said, both a state and a territory of Wisconsin. Since the Wisconsin Constitutional Convention, Stillwater was a "hotbed of St. Croix separatism." The lumber company agent, William Holcombe, was the only St. Croix County delegate to the convention. He lobbied for the continuance

of Wisconsin Territory. Secretary of State James Buchanan offered "no opinion," while Catlin assumed the governorship of Wisconsin Territory.

In Morris's anthology, Hanks recalled the Stillwater Convention:

> *In 1848, Wisconsin Territory was to be made a State. The people there wanted to take all the land into the new state that was east of the Rum River. We fellows in Stillwater and St. Paul wanted a territory of our own. As we were only two towns, we wanted the capitol of the new territory for one and the penitentiary for the other. In the Spring—in May, I think, I know it was so cold that we slept in heavy blankets, the men from St. Paul sent for us and about forty of us fellows went over.... The next day, we talked over the questions before mentioned and it was decided that we should vote against the boundary as proposed and have a new territory and that St. Paul should have the capitol and we the penitentiary. This decision was ratified at the convention in Stillwater, the last of August 1848.*

Rice and Sibley competed for the position of delegate. Sibley was elected by a large margin as "delegate of the alleged Wisconsin Territory," wrote Lass. On November 4, Catlin issued Sibley's election certificate. Sibley was advised to act as "lobbyist," not delegate, from Wisconsin Territory. Lass wrote:

> *Finally, the House ended the charade by defeating the motion. The meaning of the discussion and rejection was clear: Sibley had been seated as a courtesy. The House was to give him the podium from which he could work for the organization of Minnesota Territory, but he would have to move with dispatch, for even his strongest supporters did not care to be saddled with the embarrassment of "Wisconsin Territory" for long.*

Sibley was seated by a house vote on January 15, 1849. He was permitted by a 124-to-62 vote, but the notion of Wisconsin Territory was defeated; he was seated as delegate from Mendota, formerly Iowa Territory. Iowa became the twenty-ninth state in 1846. Senator Douglas's intervention prevented the border from extending to the Falls of St. Anthony.

In state politics, fur traders Rice, Sibley, Hercules Dousman of Prairie du Chien and Pierre Chouteau Jr. faced off against lumbermen from Maine and New Hampshire after the pine lands were ceded by the 1837 treaties. After the convention, according to Rhoda R. Gilman in *Making Minnesota Territory*, "most of the land still belonged to the Dakota and Ojibwe tribes, and the scattered white population of traders, missionaries, government

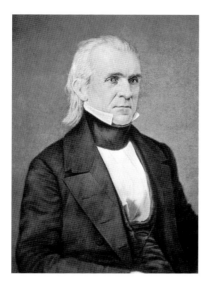

James K. Polk signed the bill that created Minnesota Territory on May 3, 1849. *Wikimedia Commons.*

agents, and a few lumberjacks was far from the minimum of 5,000 required for territorial status." Local political power grew while outside forces pushed for territorial status.

Senator Douglas created Minnesota Territory in the final hours of the Polk administration; President James K. Polk signed the bill on May 3, 1849. Washington County was one of the original nine Minnesota counties created on October 27, 1849. Anne R. Kaplan and Marilyn Ziebarth wrote in "Making Minnesota Territory": "Lines were drawn on a map enclosing lakes and rivers, prairie and woods, hills and valleys. Officials were appointed, local men grappled for power, and a European-American grid of law was officially imposed on the new entity." In addition, in Minnesota, six land offices were established. One moved to Stillwater on July 1, 1849, with A. Van Vorhes serving as register; offices also existed in Winona, St. Paul, Red Wing, Sauk Rapids and Brownsville. As William H.C. Folsom said, "The Organization of the territory of Minnesota in 1849 naturally gave a new impetus to settlement, and marked an era in the progress of the settlements already made."

After the convention, Stillwater's position was cemented. A vigorous debate occurred about the location of the territorial prison and the capitol. The *Minnesota Pioneer* said on Friday May 24, 1851, that Henry M. Rice struck Stillwater from the bill and substituted St. Paul as the prison location. The motion failed. Then, Rice moved for St. Anthony but was rejected. John W. North countered that the bill would be reconsidered the next week. But Michael E. Ames, Speaker of the House, suggested locating the capitol in Stillwater. The city declined.

Stillwater was considered an undesirable prison site by opponents because it lacked a central geographic position in the territory. Despite opposition, the *Minnesota Pioneer* printed the law signed by the legislature on May 29, 1851. It contained "an act to provide for the erection of Public Buildings in the Territory of Minnesota." An oversight commission was created. The paper

continued, "The Commissioners elected to superintend the performance of all contracts for labor and materials required in the erection of the Capitol Buildings and the Territorial Prison as required."

THE PANIC OF 1857 AND THE THIRTY-SECOND STATE

Stillwater developed at a manic pace. East Coast investors happily forked over capital to speculators to get wealthy. Unfortunately, cooler heads did not prevail, and speculation outstripped actual development. The panic spread, and reality sank in; overnight, the economy collapsed. Money was scarce for all classes. After these calamitous events, Minnesota received statehood.

Stillwater, St. Anthony and St. Paul vied for regional preeminence. Logging asserted Stillwater's position. As Wingerd said, "In 1857, 140 million feet of logs passed through the St. Croix boom alone." She continued:

> In 1857, as politicians geared up for the constitutional convention, Minnesota's future had never looked brighter. In two years the territory's population had grown by 150 percent, topping 150,000 residents, and in-migration showed no sign of slowing. Along with the speculators and hustlers who thronged the levee of St. Paul, European immigrants jostled American-born settlers, all eager to snap up farmsteads in the Suland or the fertile prairie immediately north of St. Paul. River towns up and down the St. Croix, Mississippi, and Minnesota rivers were bustling, with Stillwater, Marine, Sauk Rapids, St. Cloud, Red Wing, Winona, St. Peter, and Mankato all awash in metropolitan dreams.

Other signs pointed in unstable directions—between 1855 and 1857, approximately 700 settlements were platted with accommodations for 1.5 million settlers. But most existed only on paper, created by speculators. James Taylor Dunn described these "paper towns":

> Had it not been for the disastrous financial panic in late 1857 and the precipitous end throughout the Midwest of a land speculation boom, residents along the St. Croix Valley might today be living in such villages as Amador, Alhambra, Nashua, Fortuna, Neshodana, Drontheim and Sebatana. During the mid-1850s each of these townsites was the surveyed and platted brainchild of one or more visionaries who hoped for suitable compensation from the sale of building lots.

Swedish author Vilhelm Moberg's protagonist, Karl Oskar, insightfully described the Panic of 1857. *Wikimedia Commons.*

Vilhelm Moberg's protagonist Karl Oskar said in *The Settlers*, "Cities had begun to spring up in America like mushrooms on a rainy August day. In Minnesota Territory no less than eighty town sites had been planned and surveyed during the last year." He wrote:

> *Nearly all the towns out here existed only on maps. No people lived in them, for there were no houses. The paper cities were founded by speculators who were too lazy to work the earth and merely speculated in lots. Parasitical critters who lived off honest settlers!*

Speculators platted land while prices precipitously increased before the Panic of 1857. Stillwater survived the panic, although businesses openly admitted their inability to pay debts to creditors in local newspapers.

Minnesota—the thirty-second state—received statehood on May 11, 1858. The *Stillwater Democrat* printed Governor Henry Sibley's entire address on December 17, 1859. He recapitulated the state's difficulties:

> *When Minnesota entered upon her existence as a sovereign State of the Union, our own country as well as the nations of Europe, was suffering from the effects of a financial crisis, almost unprecedented in severity. The entire fabric of commercial confidence and credit had been shaken to its foundation, if not absolutely destroyed, and our State, in common with the other portions of the confederacy, was the most injuriously affected thereby. Foreign immigration, so essential to the development of our resources, and the enhancement in value of the taxable property in our infant State, was entirely checked. Eastern capitalists ceased to invest their funds among us, operations in real estate were suspended, our lumbermen failed to receive an adequate return for their labor, and our cultivated fields, usually so prolific, seemed for a time to deny our farmers that abundance of return which they were accustomed to yield.*

LUMBERING

One seemingly inexhaustible raw material attracted eastern lumbermen— white pine. To their eyes, and to those of absentee investors, the abundant pines represented an inexhaustible financial opportunity. For lumbermen, employment opportunities compelled thousands to Stillwater. Captain Edward W. Durant wrote in "Lumbering and Steamboating on the St. Croix River," from *Minnesota History* in 1906, "Beyond any question the lumber district of the St. Croix possessed advantages unknown in any other lumbering locality." One distinct advantage was the network of tributaries feeding the St. Croix, from the Willow and Apple Rivers on the Wisconsin side; to the Sunrise, Snake or Knife Rivers and more on the Minnesota side.

The first lumber was rafted to St. Louis and Hannibal, Missouri; Clinton, Iowa; and destinations south. As John Fraser Hart and Susy Svatek Ziegler pointed out in *Landscapes of Minnesota: A Geography*:

> *Most of Minnesota's earliest towns were on navigable rivers that connected them with markets and manufacturers in the older settled areas to the east. In 1860 these river towns included Winona, Red Wing, Hastings, St.*

Paul, and Minneapolis on the Mississippi; Stillwater on the St. Croix; and Mankato on the Minnesota.

Treaties with American Indians opened additional land to the industry in the north and west. Moreover, astronomical timber production caused a corresponding population boom. From lumber towns in the East, men produced materials for building homes on the frontier.

Stillwater developed a reputation as a lumber leader. Ellet wrote:

> [Stillwater] *settled some eight or ten years, stands at the head of the lake, and is the great mart for lumber of the St. Croix, commanding an extensive and rich farming country. It is picturesquely situated at the foot of a circular range of hills, at the lower end of which the heights become precipitous, and are capped with turret-like masses of rock fifteen or twenty feet in depth, extending around the whole summit of the bluff.*

Lumbermen and government worked in tandem while industrial capitalism transformed the St. Croix River and Stillwater. President Zachary Taylor signed an executive order: Ojibwe's fishing and hunting rights on ceded lands ended on February 6, 1850. McMahon and Karamanski said, "Lumbermen attempted to transform the free-flowing wild river into a disciplined industrial waterway. Never before and never again would the river be used so intensely." They added, "The early lumbermen more than doubled the natural transportation capacity of the St. Croix watershed to 330 miles of water capable of carrying logs to market."

The lumber industry nurtured allied industries. These businesses included forty saloons, brothels and houses of prostitution. Prostitutes traveled from St. Paul—or St. Petersburgh (later Houlton, Wisconsin)—where infamous characters like "Red Nell," Harry Mandeville and Mack Fortune promoted "the world's oldest profession." At Aiple's brewery on the south of Main Street, a saloon row commenced that snaked up Chestnut and Myrtle Streets.

The lumber industry diversified the industrial economy. Norene Roberts in *North Hill (Original Town) Stillwater Residential Area* said, "Lumbering played an important role in the economic development of the town in the nineteenth century. It financed the flour milling industry, railroad construction, manufacturing, and was critical in the growth of banking, insurance, and other financial enterprises in town." Stillwater emerged a regional—and national—lumber leader.

THE SECOND BOOM AND HISTORIC STILLWATER LUMBER MILLS

Stillwater's status as a regional logging center was reinforced by the second boom. St. Croix Valley loggers built state-of-the-art lumber mills and the most profitable boom in the Midwest. Unlike water power battles between St. Anthony (east side) and Minneapolis (west side) at the Falls of St. Anthony, in Stillwater, the location of the site did not solely determine success. Waterpower was a less significant factor because Stillwater adopted the latest technology—steam power.

In 1856, the second boom was constructed. After arriving from Maine, Isaac Staples led the boom company in 1854. He immediately recognized the Osceola, Wisconsin, boom's inadequacy. William H.C. Folsom (Taylors Falls) was involved in the first and the second boom. This was surprising since, as McMahon and Karamanski wrote, "towns like Taylors Falls, Marine, and Franconia suffered economically as they were shut off from downriver trade."

The site—two miles north of Stillwater—handled the tremendous volume of white pine scaled. In Stillwater, a new lumber milling age commenced, and volume dramatically increased, except during drought years (1862–64). As Hart and Svatek Ziegler wrote, "The first sawmills were built at Marine on the St. Croix in 1839 and at Stillwater in 1844; within ten years Stillwater had five more. These mills were powered by steam raised by burning wood scrap." During these years, in Stillwater, three hundred to four hundred men sorted, rafted and scaled logs in the spring, summer and fall.

Visionary businessman Isaac Staples predicted the trajectory of Stillwater. As McMahon and Karamanski said:

> *Logging introduced urbanization to the St. Croix Valley. Milling and transportation concentrated the harvest of wood on specific, reoccurring locations. Initially these were waterpower sites on the lower river such as Taylors Falls and Marine. Eventually most of the energy of the logging frontier focused upon Stillwater, and it grew to a city of more than a dozen mills and thousands of inhabitants, the majority of whom were beholden to the forest for their livelihood.*

Staples also recognized favorable conditions for lumbering. He understood, as Larson wrote in *The White Pine Industry*, that "nature had... endowed Minnesota with a magnificent system of waterways which provided highways for carrying her resources to market." She continued, "The St.

Croix River had much to offer. Born in the midst of millions of mighty trees, the St. Croix River was to become second only to the Mississippi as a carrier of logs. Its energy, also, would make logs into lumber." Staples, not surprisingly, was Minnesota's first multimillionaire.

Born in Topsham, Maine, on September 25, 1816, Staples arrived in Stillwater in 1853. McMahon and Karamanski wrote, "Of all the lumber barons of the St. Croix, the most powerful was the barrel-chested, bald-headed Isaac Staples." After visiting Stillwater, Staples convinced Samuel F. Hersey in Maine. "There his salesman's talk was evidently given with conviction, for, on his return to Stillwater, the Herseys, old lumbermen in Maine, began to invest in the Eldorado of the West," according to Larson in "When Logs and Lumber Ruled Stillwater."

He purchased 40,000 acres of St. Croix Delta pineland in October 1853. His company purchased land warrants from Mexican-American War veterans at a 75 percent discount, while the U.S. government charged $1.25 minimum per acre. Congress passed new land warrant acts in 1847, 1850, 1852 and 1855—the last providing 160 acres for veterans. Only one in five hundred located on the property, however. Lumber barons, like Staples, later purchased discounted tracts of land after the public domain lands of the Morrill Act (1862).

The Hersey, Staples & Company was formed on June 1, 1854. With the eastern capital—Samuel F. Hersey—receiving top billing, Staples assembled their lumber mill. Samuel and Nancy Leech purchased 32.5 acres at the St. Croix Falls land office on April 2, 1849. The Leeches sold to Henry Crosby in July 1853. Crosby then sold to brewer Norbert Kimmick, who retained the hillside cave and spring. Staples purchased the remainder and deeded the property to Hersey. Mill construction was delayed, and in the spring of 1855, Staples shrewdly sold lots. The eighteen-block Hersey, Staples & Company Addition was platted.

Staples found success with the capital of his absentee partner. "Within seven years after he arrived at Stillwater, his company had purchased two hundred thousand acres of pine forests on the St. Croix and its tributaries," wrote Larson in "When Logs and Lumber Ruled Stillwater." McMahon and Karamanski added:

He had created the powerful St. Croix Boom Company and controlled its vital operations through his ownership of its stock. He was the valley's biggest and most successful farmer, and as president of the Lumberman's National Bank, he was one of its most important bankers. Minnesota politicians

anxious for advancement courted Staples's favor while throughout the valley thousands of breadwinners traced their paychecks to his enterprises. He arrived as a stranger in 1853 and remained to flourish as the presiding patriarch of St. Croix logging for the next generation.

The younger of the two partners, Staples was the consummate and practical businessman, and his partner excelled in politics.

Samuel Freeman Hersey was born in Sumner, Maine, in 1812. After three years as a schoolteacher, he entered the lumber business. He lived in Upper Stillwater, Maine, but never resided in Stillwater, Minnesota—unlike two sons. Hersey remained in Maine and made a fortune. The politician served in the Maine House and Senate. Later, in the U.S. House of Representatives, he was a delegate to the Republican National Convention.

Hersey and Staples adopted state-of-the-art technology. Larson, in her article, said, "Steam was coming into its own. Steam as power was superseding the limited power of the water-driven flutter wheel." Lumber scraps were abundant as fuel for steam power. The author continued:

The first-class Hersey mill had another improvement over the other mills: it was equipped with a gang saw. Gang saws were parallel sash saws, with many in one frame. This mill had one frame which could hold twenty saws. It also had a circular saw which cut 16,000 feet of lumber in eleven hours.

She elaborated, "Thus, equipped with a gang saw and circular saw, as well as with three of the usual upright saws, the Hersey, Staples mill could produce 125,000 feet in twenty-four hours." The steam sawmill cost $80,000. The circular saw was another technological advance.

At various times, the firm reorganized. In 1861 the company was renamed Hersey, Staples & Hall. Dudley Hall retired in 1866. Jacob Bean became a partner. Hersey, Bean & Company was formed when Staples sold his shares for one year (1871). On July 16, 1869, Staples purchased the St. Croix Mills on the north end of the downtown waterfront while remaining a partner in Hersey, Staples & Bean until 1875. He added the St. Croix Flouring Mill (forty by fifty feet and four stories high) beside the lumber mill in 1866. Staples employed 175 men at the mill and produced 250 barrels of flour per day until 1883. Then, the Northwestern Manufacturing & Car Company purchased the flour mill. Months later, J.H. Townsend bought the property for $54,200.

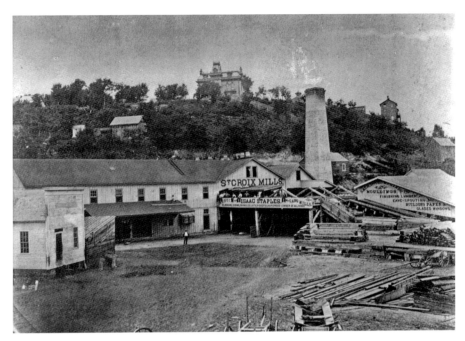

Isaac Staples's mansion overlooked his St. Croix Mills within present-day Pioneer Park. *The St. Croix Collection.*

Hersey, Bean, & Brown (established in 1872) was another partnership. The next year, a mill was added one-eighth of a mile south of Stillwater, with a 367-foot smokestack. Following Samuel F. Hersey's death in 1875, his sons formed Hersey and Bean, and then Hersey, Bean and (Edward S.) Brown, with the former mayor of St. Anthony in 1873.

Staples and Hersey built a business empire. As Empson wrote in *Hersey, Staples Residential Area*, "The company not only dealt in timber lands (34,000 acres were purchased in 1858) and the mill to cut the timber; they also purchased woodlands, farm land, boom islands, waterpower and dam sites, as well as town lots in Stillwater, Hudson, St. Paul, Hastings, Red Wing, and Winona." Staples was a shrewd speculator with diversified business interests that included flour milling; hardware and dried goods; farming at the three-thousand-acre Maple Island and eight-hundred-acre Oak Glen; banking, including Lumberman's National Bank and Second National Bank in St. Paul; railroads, such as St. Paul, Stillwater & Taylors Falls; and real estate. Larson, in *The White Pine Industry*, described the company's vertical integration:

Hersey, Staples and Company in the early days became owners of standing timber; they were loggers; they were manufacturers of lumber; they were wholesale distributors; and they were retailers as well. Apparently they carried on all the branches of the lumber industry, a highly integrated business.

The Sawyer & Heaton Lumber Mill was the city's second lumber mill in 1850. Originally, Seth Sawyer and Alvah Heaton organized the steam-powered mill, which was destroyed by fire in 1852. Soon rebuilt, Heaton sold to William Lowell in 1853. In another shakeup, he returned with a third partner, forming the (William) Clay, Sawyer & Heaton Company in 1855. Samuel J. Atlee & Company purchased the mill on November 8, 1865. Finally, Staples purchased the mill.

In 1854, Frederick Schulenburg and Adolphus Boeckeler organized in Stillwater. Kathleen Neils Conzen wrote in *Germans in Minnesota* that Schulenburg and Boeckeler "bought the first raft of pine logs sent down the Mississippi from Wisconsin pineries. Five years later, Schulenburg came upriver to Stillwater to locate a sawmill for the firm closer to the pineries, and soon the Schulenburg and Boeckeler mill was the largest in the state." They purchased part of Brown's former claim after arriving in 1853—and rafted logs to their St. Louis lumberyards. As Larson said in *The White Pine Industry*, "Their mill in Stillwater sawed exclusively for the St. Louis market." Boeckeler served as manager in Stillwater. In 1854, Louis Hospes (1809–1888), born in the landgraviate of Hesse-Cassel, Germany, relocated from St. Louis to Stillwater and, eventually, became a partner in the company.

The mill led the region. "It beat any mill in the rival town of St. Anthony. Schulenburg and Boeckeler were setting the pace in the state with their output; in 1866 the firm cut 15,000,000 feet in 197 working days," wrote Larson. In 1871, production exploded when twenty-six million feet of lumber were milled, and by 1874, an astonishing thirty million feet were completed. Larson said, "Stillwater did not have so many sawmills as Minneapolis, but it had mills which in production surpassed any one Minneapolis mill in the 1870s."

Moreover, the company excelled selling logs downriver. W.A. Blair called the *Helene Schulenburg* "a splendid boat." According to Larson, in "1871 *The Molly Whitmore* captained by Bob Dodd, took a lumber raft of 2,000,000 feet for Schlulenburg, Boeckeler, and Company from Stillwater to St. Louis, returning in sixteen and a half days."

The company was incorporated in St. Louis in 1880. But fortunes soon turned. Finding good timberland was increasingly difficult, and a fire occurred about one year before the Panic of 1893. When the U.S. economy crashed, the original ownership had died—Boeckeler in 1893 and Schulenburg in 1894. In 1901, George H. Atwood purchased the mill, renamed the Atwood "B" Mill.

The East Side Lumber Company partnered James S. Anderson, William McKusick, John G. Nelson and Alex Johnson in 1869. Directly across the river from downtown Stillwater and just south of the Interstate Lift Bridge, the mill was incorporated in 1888—this time, under the financial leadership of John G. Nelson, Alex Johnson, Robert Slaughter, David Bronson and E.A. Folsom.

The C.N. Nelson Lumber Company was another Stillwater logging business. Beginning in 1878, the 36- by 150-foot lumber mill with twenty-one gang saws cut logs into planks; but when the lumber industry moved north and west, the company relocated to Cloquet, Minnesota. In 1896, it was sold to the Frederick Weyerhaeuser conglomerate.

RAFTING LOGS AND LUMBER

The lumber business was seasonal: lumberjacks logged in the winter and rafted during the summer. Timber was transported to the tributaries and rivers that flowed to the boom. Feeding hungry lumberjacks presented a daily problem, as McMahon and Karamanski noted: "The biggest challenge to the early lumbermen was supplying their camps." Captain Hanks returned from St. Louis with "several tons of beans, hominy, eggs and dried apples" but without pork, the staple food. At lumber camps, abundant and hearty food fueled the workers.

Skilled axe men marked logs with the owners' identification symbol before rafting. Then a "scaler" measured logs in feet, and a "tallyman" recorded the number of feet. Captain Stephen Hanks recalled the following for Lucy Morris:

> When we got to St. Croix Falls, I thought it was a real metropolis, for it was quite a little town. I was back and forth across the river on the Minnesota side too. In 1843, I helped cut the logs, saw them, and later raft them down the river to St. Louis. This was the first raft of logs to go down the St. Croix river.

Before tow boats were introduced, "cordelling" was an unpredictable means of transportation. Durant called the process "crude and exceedingly laborious." It included makeshift sails made of "shanty boards on end and tying blankets on poles in such a manner that they would catch the breeze."

Steamboat rafting was faster. Edward Durant was a leading towboat driver in Stillwater. Born in Roxbury, Massachusetts, he moved to Albany, Illinois, with his family. W.A. Blair apprenticed "rafting" with Hanks and Durant. In *A Raft Pilot's Log*, Blair said, "[They] learned the river while pulling an oar on floating rafts before steamboats were used to tow them." Lumber was rafted in strings, cribs and courses, sometimes eleven, twelve or thirteen courses deep. Durant wrote of the eight-hundred-mile trip between Stillwater and St. Louis (Larson said seven hundred miles). Today, the mileage is approximately six hundred miles by freeway. The route was altered and improved, so distances varied. Durant said about the trip,

> *In my opinion, the knowledge and skill of the steamboat and raft pilots, considering the length of the stream traversed, the then condition of the Mississippi river, unimproved, before government lights were placed for the guidance of the pilot, the vast number of boats, and the large number of rafts then passing down river, are without parallel in the history of navigation.*

Of the size and value of rafts, he said, "Boats have taken rafts from Stillwater containing 5.4 million feet of lumber, heavily laden with lath, shingles, and pickets, a cargo valued at $60,000" (in 1906 currency).

Technology and administration improved the economic efficiency of logging. In the 1870s, the crosscut saw replaced the axe. After 1867, governors appointed "Surveyor Generals" of logs in seven districts. Scalers of logs recorded and received five cents per one thousand board feet.

During the era's zenith, ads appeared regularly in the local newspapers. The *Stillwater Democrat* stated in 1887, "Rafts run to any point on the Mississippi north of St. Louis." Blair described a rafting company:

> *Captain A.R. Young, of Stillwater, Minnesota, had the largest and most powerful of all the raft-boats. She was called the "Tow-boat Minnesota," to distinguish her from the side-wheel steamer of the same name, a Saint Louis packet. Her engines were sixteen inches by six feet. She was used in floating-raft days, to float tow fleets of rafts through Lake St. Croix and Pepin.*

THE STEAMBOAT ERA

The steamboat was the primary means of transportation and shipping until after the Civil War. Conveyances were slow by horse, coach or wagon on the shoddily constructed roads. Roads were also scarce and impassable—so steamboats were the reliable solution.

St. Paul and Stillwater established a coach line in 1848. James M. Goodhue in the *Minnesota Pioneer* wrote that the Territorial Road bill, to create a road from St. Anthony to the St. Croix, passed after a third reading on January 30, 1851. Local boosters and businessmen celebrated the St. Paul Road that followed the approximate course of Olive Street—but it took another five years before it was completed.

The steamboat faced one major obstacle: inclement weather. However, during pleasant conditions, according to Anita A. Buck in *Steamboats on the St. Croix*, "For three-quarters of a century, steamboats throbbed the pulse of the old St. Croix Valley as the principal means of communication, travel and shipping."

Rapidly, steamboats asserted a presence in Stillwater. The *Palmyra* first plied the St. Croix from Hannibal, Missouri, in June 1838. The steamer landed at Taylors Falls in July 1838. J.W. Bond wrote in 1854, "There come the steamboats, either on their way up or down the Mississippi; and although you might go across in stage from Stillwater to St. Paul by land, you will probably prefer to go around in the boat." Nearly every pioneer traveled by steamboat. Mrs. Samuel B. Dresser reported to Morris in 1850, "We took a steamer from Galena to Stillwater, as everyone did in those days." She had traveled as a seven-year-old by bateaux, eventually to Taylors Falls.

In the 1850s, twenty-five steamboats regularly carried passengers from Stillwater to Marine Mills, Osceola and Taylors Falls. As Dunn stated, "Steamboat excursions were an important, even an essential, part of river life for many years." But, he continued, "it's hard to imagine that steamboats of sizable tonnage could possibly have navigated the treacherous, shallow sand bars of the St. Croix."

Navigation was a formidable risk. George B. Merrick in *Old Times on the Upper Mississippi* recalled the wreck of the *Equator*. Uneventfully, the sojourn began with three hundred passengers on the 120-ton stern-wheel boat in April 1858. Near Catfish Bar (across from Afton on the Wisconsin side of the river), "the sweep of the wind had raised a great sea, and the heavily-laden boat crawled ahead into the teeth of the blizzard—for it began to snow as well as blow," Merrick wrote mellifluously, like his namesake, George, Lord

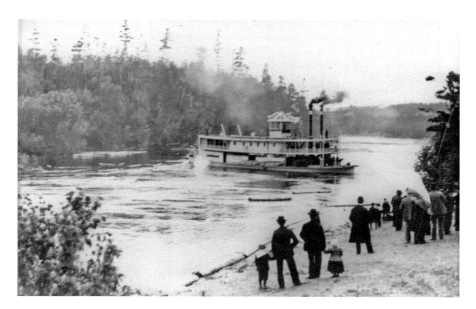

In 1838, the *Palmyra* was the first steamboat on the St. Croix River. *The St. Croix Collection.*

Byron. In *A-Rafting on the Mississippi,* Charles Edward Russell said, "He was not only a notable historian himself but the cause of much history writing by others." Merrick continued, "As soon as the wheel stopped the boat fell off into the trough of the sea. The first surge caught her on the quarter, before she had fully exposed her broadside, but it rolled her lee guards under water, and made every joint in her upper works creak and groan."

The situation worsened. Merrick continued:

> *Women and children screamed, and many women fainted. Men turned white, and some went wild, scrambling and fighting for life preservers. Several persons—they could hardly be called men—had two, and even three, strapped about their bodies, utterly ignoring the women and children in their abject selfish panic. The occasion brought out all the human nature there was in the crowd, and some that was somewhat baser than human.*

After an hour, the boat drifted ashore. Merrick said, "Her bones are there to-day, a striking attestation of the power of wind and wave, even upon so small a body of water as Lake St. Croix."

Russell told a similar story but recalled major differences in details in his book. He remembered that the incident occurred on May 26, 1859, and noted, "It might have been a real tornado." Not a blizzard? Not in April? He concluded that Merrick "had the wisdom enough to see that his job was to try to hold the *Equator*'s head up to the wind, but he knew also that nothing could save her." Also, Captain Charley Jewell asserted that Merrick was only a "Cub," or mate.

Steamboat traffic grew with increased shipping of settlers, goods and farm animals. During a seven-month period in 1869, 230 steamers with timber traveled down the St. Croix River. In 1869, *The Minnesota Guide*, edited by J.F. Williams, attested, "Steamers of the largest class, from St. Louis and La Crosse, land here almost daily, while there are two regular lines on Lake St. Croix, touching at Stillwater."

In 1871, the notorious Battle of the Piles occurred, a conflict between two modes of transportation and border cities. The Wisconsin Railway Bridge was located on the east side of Lake St. Croix. The railroad constructed a bridge in Wisconsin. Furthermore, Dean Thilgen writes in *Valley Rails: A History of Railroads in the St. Croix Valley*, "bitter Stillwaterites soon noticed that the construction was going to be a nuisance, a danger to the men who floated rafts downstream." The steam pile driver placed piles too close. Judge McCluer issued an injunction, halting bridge construction. Meanwhile, "rivermen" used a steam engine to pry out approximately one hundred piles. Finally, a peace treaty was signed at Sawyer House on July 18, 1871. A compromise was reached on the 136-foot bridge—pilings were limited.

Railroads developed slowly while steamers still controlled river traffic. The *Mississippi Valley Lumberman* wrote on August 12, 1887:

> *At the beginning of the present season there were ninety steamers in commission on the river between the mouth of the St. Croix and the city of St. Louis whose only traffic was in connection with the lumber business. Less than twenty packets engaged in ordinary passenger and freight traffic have been meantime plying the stretch of river between St. Louis and St. Paul.*

Boat works were abundant in the steamboat era, but over the years, one remained. Once located on the present site of the Stillwater Yacht Club, for five generations the Muller Boat Works built all types of boats. In 1873, Pennsylvania coffin maker Philip Muller opened a shop, at a time when tugboats and steamers were largely crafted by hand.

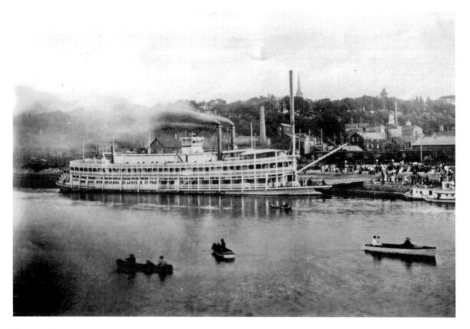

Even after the railroad arrived in the 1870s, steamboats remained a reliable method of transportation. *The St. Croix Collection.*

George Muller designed the *Olive S.*, a popular passenger boat that traveled between Taylors Falls and Stillwater. It was "built" by James Teare. In an article, "The Olive S. on Her Maiden Trip," the *Daily Gazette* of May 10, 1916, wrote that "the boat will meet all expectations, and further that she will have all she can do carrying passengers between this city and the Falls." It was described as a "fine little craft," but smaller boats signaled the beginning of the end. The Muller family remained in business until 1986.

BREWING

In the mid-nineteenth century, specific conditions were necessary for a brewery. Doug Hoverson wrote in *Land of Amber Waters*:

> *Minnesota Territory had only three settlements large enough to support any sort of commercial business: the territorial capital St. Paul and two rival lumber towns of Stillwater on the St. Croix River and St. Anthony on*

the Mississippi River. All three possessed access to a river, access to raw materials, potential storage caves, and a population large enough to make a small brewery a possible source of profit.

Anthony Yoerg started Minnesota's first brewery in St. Paul. The following year, two Minnesota breweries opened, John Orth of St. Anthony and Norbert Kimmick of Stillwater.

Kimmick first operated a whiskey still at Third and Chestnut Streets in 1851. At age twenty-two, Sussanah Burkhard arrived in Freeport, Illinois, from Germany. In 1849, she married Kimmick and settled in Stillwater. The couple regularly brewed beer in 1852, and quickly expanded. Kimmick hired Frank X. Aiple in 1854. Sadly, Kimmick died in 1857. Sussanah oversaw the brewery, and Frank "supervised" operations. In January 1860, Aiple married Sussanah.

Despite tragedy, the brewery again expanded. Northwestern Brewery produced 120 barrels of beer per month by 1865. Once again, disaster struck. A fire destroyed the brewery in 1868. The *Stillwater Democrat* did not mention the incident until July 4, 1889:

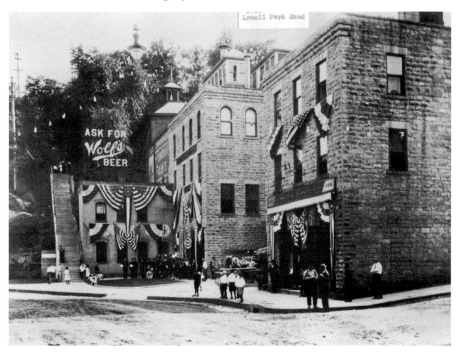

The Joseph Wolf Brewing Company was the only Stillwater brewery that survived until Prohibition. *The St. Croix Collection.*

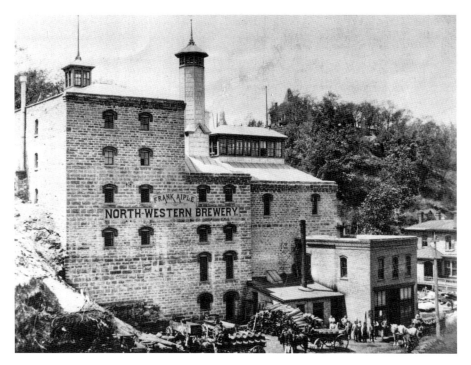

The Northwestern Brewing Company persisted despite numerous tragedies. *The St. Croix Collection.*

Frank Aiple [Jr.] has gone to Chicago where he will arrange matters for the construction of a large and well equipped brewery on the site of the one lately damaged by fire. The walls of the old building will be raised another story. The structure will be fitted with all the latest and best machinery and the improvement will cost about $40,000.

On June 5, 1889, the *Gazette* published an Aiple Brewery ad, "Damaged malt for sale." It continued, "Cheap, and must be taken away at once. Inquire at office of Northwestern Brewery."

Frank X. Aiple died on November 17, 1868. The *Stillwater Republican* obituary said he "continued to manage his business and by his thrift and industry kept adding to and building it up until he had probably the most extensive brewery in the St. Croix Valley." Following the previous year's fire, he rebuilt and expanded. The *Republican* continued, "There are few men in our city that have more friends than Mr. Aiple. He was one of those free,

open hearted, generous men, that everybody likes when once they become acquainted with them."

Once again, Sussanah resumed brewery operations. After the customary year of mourning, she married Herman Tepass in December 1869. The couple operated the brewery until 1887. Later, they formed Aiple & Piper (1887–1889). Sussanah Tepass died on June 4, 1889. Frank Aiple Jr. operated the business until 1896 and as Aiple Brewery until 1899. Milwaukee's Jung Brewing converted the brewery into a malt house until Prohibition.

Joseph Wolf Brewing Company began in 1868. The brewery survived numerous iterations on Main and Nelson Streets. Joseph Wolf was born in Turns, Switzerland, on January 4, 1832. After working for his brother Martin Wolf (1869–71), he purchased with a partner and renamed a brewery: Wolf, (Joseph) Tanner, and Co. The brewery frequently changed names: Joseph Wolf & Co. (1875) and Empire Brewery (1879). The state's seventh-largest brewery produced 2,651 barrels in 1878. A year later, it was "the largest brewery in Minnesota outside of Minneapolis and St. Paul," said Hoverson. Charles E. Dick, in his University of Minnesota dissertation, said, "The brewery, which utilized natural white sand-rock cellars on the side of the St. Croix River Valley, increased its annual capacity to twenty-five thousand barrels by 1901."

To grow market share, breweries advertised. The *Washington County Journal* of April 19, 1912, included Joseph Wolf's ad: "Let us send you a case." In Stillwater papers, increasingly sophisticated ads appeared as the industry-consolidated Hamm's brewery from St. Paul began to compete. Wolf was more persuasive in the *Gazette* of May 15, 1913: "Stalwart men," with a classy illustration of a worker, "Drink beer. The great middle class of intelligent, industrious workmen in the million workshops of the world find that its cheer makes their work a pleasure and its strength feeds their muscles for the tasks they have to perform."

Wolf consolidated in March 1896. Production increased until Prohibition. Dick wrote,

> *Among larger Minnesota breweries of 1919 which went out of business were the Schuster Brewing Company of Rochester (50,000 barrels), the Joseph Wolf Brewery of Stillwater (25,000 barrels), the Purity Brewing Company of Minneapolis (18,000 barrels) and the Jac. Kiewel Brewing Company of Crookston with an annual capacity of 18,000 barrels.*

Knips was Stillwater's third brewery, also known as St. Croix Brewing. Gerhard Knips began brewing in Dutchtown (circa 1858–59). Regularly, Knips ran blunt ads, such as in the *Stillwater Messenger* (circa 1864–65): "Mr. G. Knips would beg leave to inform all lovers of GOOD, PURE BEER, that he has enlarged and thoroughly repaired his brewery." It continued, the "Best A ticle of Beer." Weekly, the typeset was sans an "r" and not repaired. The brewery lacked advertising slickness, but it rivaled Aiple in production until after the Civil War. A fire occurred at Knips on January 2, 1866.

Knips was leased by Fred Maisch, D. Milbrook and Joseph Homar in 1877. Louis Hospes of Schulenburg & Boeckeler purchased the brewery in 1878. It was then sold to Seymour, Sabin & Company in 1880—this time as a boardinghouse. Finally, Minnesota Highway 95 was widened in 1935–36. The brewery was demolished, except the back wall—today, a retaining wall with the Joseph R. Brown plaque is at the wayside rest.

THE PONTOON BRIDGE

The Stillwater Bridge Company was organized on March 6, 1857. Frank R. Delano, William H. Mower, J.D. McComb, John S. Proctor, L.E. Thompson, William McKusick and T.E. Parker financed the span that connected the east and west banks of the St. Croix by wagon, and later, automobile. The group procured $40,000 in capital, but the $25,000 of bonds for the bridge was not issued until March 9, 1875.

The measure was approved by 693 votes. John Lawler of Prairie du Chien was contracted to construct the bridge on April 11, 1875. In 1876, it was completed for $24,000. It was a 1,500-foot, wooden toll bridge with a 300-foot pontoon draw, 200-foot trusses and ten 60-foot spans. Upon completion, it was immediately deemed inadequate for transportation and a fire hazard.

Predictably, the pontoon bridge caught fire on September 15, 1904—two men and two fire horses were killed. The conflagration consumed the east span of the bridge. Local boat builder George Muller repaired the bridge while the clamor for a safer bridge grew cacophonous.

IMMIGRATION

The St. Croix Valley lumber industry required workers, and immigration was the answer. Following the expropriation of American Indian lands,

After the completion of the pontoon bridge, it was considered inadequate and needed to be replaced. *The St. Croix Collection.*

only the French, British and American fur traders and Métis remained. When the region opened for settlement, New England's "Yankees and Yorkers" staked claims.

Immigrant literature recruited Europeans. In 1853, J.W. Bond described Minnesota: "The whole world can not produce a climate more salubrious than that of Minnesota. We have never yet known a case of fever and ague in it, nor any unwholesome water, either in wells, springs, lakes, or streams." *The State of Minnesota; Its Agriculture, Lumbering and Mining Resources* (1885) similarly attracted immigrants—and investment: "This flourishing city is very prettily located on the St. Croix river, where it empties into Lake St. Croix, occupying one of the most picturesque sites in the State."

Throughout Europe, publishers produced immigrant literature. J. Maurice Farrar's *Five Years in Minnesota* (1870) was an economic report aimed at recruiting immigrants from the British Isles. As the text admitted, "The object of these pages is to show to many classes in England…emigration is the remedy." His objectivity was described in the introduction: "Should the following pages

appear to some readers like descriptions of an impossible paradise, they are, at any rate, fully borne out by the letters of the special correspondent of *The Times* accompanying the Royal British Agricultural Commission."

Moberg described the area through fictional Swedish immigrant eyes in *The Settlers*:

> *Through a treaty which the Indians were forced to accept, the land was opened for settling and claimtaking. The hunter people were forced back before the power of the transgressors. Their hunting grounds, with the graves of their forefathers, were surrendered. Virgin soil, deep and fertile, could then be turned into fruitful fields with the tiller's tools. An immense country, until now lacking any order except nature's own, was divided surveyed, registered, mapped, and separated into counties, townships, and sections. Millions of acres of wilderness were mapped on paper in square lots, each one intended as a homestead for a settler.*

The myth of uninhabited land was concocted for the immigrant farmers in the St. Croix Valley. The French Canadians, the first immigrants, created institutions upon arrival. As Sarah P. Rubinstein said in the anthology *They Chose Minnesota*:

> *To serve the influx of French-Canadian workers attracted by the lumbering industry in nearby Washington County (some had been there since before 1850), a French-language church was established at Stillwater in 1882. By 1898 it boasted a membership of 110 families and 600 persons. Its services were conducted in French until 1920, by which time many French Canadians were moving away and the congregation was becoming Italian.*

Across America, immigrant parishes followed a path similar to St. Joseph's Catholic Church.

In 1850, the Swiss resided in Minnesota Territory. Nine Roman Catholic immigrants from Glarus Canton arrived between 1848 and 1850 in Stillwater.

Stillwater's Irish immigrant population was influential. When Irish loggers followed bosses to the St. Croix, the city was an obvious place for relocation. Ann Regan described immigrants from the Emerald Isle in *Irish in Minnesota*:

> *Farmer-lumberers from Maine and New Brunswick, especially from settlements in the latters' Miramichi River Valley, came to the rich timberlands of the St. Croix River Valley after the Ojibwe ceded the land*

in the Treaty of 1837. Stillwater's Irish lumberjack families, often counted as Canadian in the census, built a church in 1853: by 1870 they made Stillwater a "Miramichi town."

St. Michael's Catholic Church represented the triumph of the Irish in Stillwater. By the mid-nineteenth century, workers tirelessly laboring found spiritual strength in the church spire overlooking the South Hill.

German culture was manifold in Stillwater. In Dutchtown—originally Charlottenburg—the lumber mills, brewery and churches converged.

Schulenburg and Boeckeler created a company town that originated at the Sycamore Street sawmill north of Stillwater. It included a company store, brewery, boardinghouse and baronial Schulenburg mansion atop the bluff. As Conzen said:

The new pineries and sawmills of the St. Croix attracted job-hungry Germans from St. Louis and other downriver settlement areas. By 1850 Washington County's 55 German men included not only laborers and lumberjacks but also a few craftsmen, a couple doctors, nine farmers, most of them family men, harbingers of the colonization to come.

Empson wrote in *Dutchtown Residential Area: Stillwater, Washington County, Minnesota*: "Schulenburg and Boeckeler retained ownership of blocks 24 through 57 of the Addition, including the entire area of Dutchtown, while Christopher Carli continued in his possession of blocks 1-23 that lay on the southern end of the Addition south of Sycamore Street." It "became known as Deutschetown, which was soon corrupted to Dutchtown." "Dutch" was from *Deutsch*, the word for German language. Charlottenburg contained settlers of diverse national origins: Swiss, Canadians, Irish, English, Danish, Swedish and Belgian. Dutchtown had fifty homes by 1860, "only five of the 89 adults in the community had been born in the United States," wrote Conzen. Germans composed 92 percent of Dutchtown's residents by 1880, and four hundred were employed in the lumber mill and yards. Empson wrote, "Since the closing of the mill in 1902, Dutchtown, with its hilly and rocky geography, became a forgotten community—without city water and sewer, largely without sidewalks, without many of the civic amenities enjoyed by the other residents of Stillwater."

In *My Hometown and Yours*, Lillian and Louise Berg recalled, "Many people who located in this area in the early days were emigrants from Germany. In some instances, entire families arrived together. In our family (Berg) our

grandparents, John Berg and his wife Augusta" and extended family moved to the Carli and Schulenburg addition, in the third ward in Dutchtown. To serve this population, there was a "German School" (at 516 West Myrtle Street) from 1894 until "anti-German sentiment of World War I" closed the school.

As the Bergs said, "Before World War I and for a time after the war every family had a picket fence around their property to keep out the cows and dogs. Most every family had a garden, plus fruit trees, apple and plum trees, currant bushes, raspberry bushes, and a strawberry patch." They continued:

> *Before World War II several new families moved into the area. The Schell family, the Placzek family, and the Doderwick family. We heard Russian and Polish spoken. Their culture was much the same as ours. They planted their gardens, exchanged recipes, and the children in the neighborhood played together.*

They also skated and swam on the river.

The Swedish were an important immigrant group. They settled in the city and, in particular, farmed the St. Croix Valley. Jacob Fahlstrom (alternately spelled Falstrom, Folstrom or Falström) was the first Swede in Minnesota. He was born in Stockholm between 1793 and 1795 and arrived in the future Minnesota Territory in 1840. Curt Brown summarized Fahlstrom's significance in his "Minnesota History" in the *Star Tribune* of August 16, 2015: "Roughly one in 10 Minnesotans comes from Swedish ancestry. That's about a half-million people who identify as Swedes—ranking fourth behind Minnesotans of German, Norwegian or Irish origin." He wrote, "Of all the Swedes, Jacob Fahlstrom came first."

Swedes immigrated and staked settlement claims. Larson writes in *The White Pine Industry:* "While Yankees from the East, particularly from Maine, were buying pinelands by the hundreds and thousands of acres in Minnesota in the middle fifties, a small group of immigrants from Sweden were buying modest plots in that area, hopeful that there they might establish homes."

In *They Chose Minnesota*, John G. Rice wrote, "Swedes were particularly important in lumbering towns as Stillwater, which was close to the early rural Swedish settlements in the St. Croix Valley." Moreover, Norene Roberts said in "North Hill (Original Town) Stillwater Residential Area": "There was also Swedish flavor to the south end of the North Hill (Original Town) in the decades before and after 1900." In addition, Swedes had significant presence in South Stillwater, as Hila Sherman wrote in *Bayport: Three Little Towns on the St. Croix:*

After the Nineteenth Amendment was ratified in 1920, many women voted in one-room schoolhouses, for example the Hay Lake School. *The St. Croix Collection.*

In the late sixties and early seventies in the nineteenth century the Swedish emigrants began to come in large numbers to the north central part of the United States. Many found their way to Bayport where they wanted a church of the Lutheran faith. Services were held in the Union Chapel or in the home. Several of the early Swedish folks walked to Stillwater to attend services there.

Italians arrived in modest numbers in Stillwater. In 1899, Archbishop John Ireland invited Father Nicola C. Odone, formerly of Genoa, to lead the Italian mission. He also ministered in Stillwater, Minneapolis, Little Canada and Duluth. Rudolph J. Vecoli wrote in *They Chose Minnesota:*

Italians living in various scattered settlements elsewhere in the state usually had no choice but to attend the local parish church. Such was the case with the small group of Lombards who settled in Stillwater in the 1870s to work in the sawmills; they joined St. Joseph's Church, which had originally been French Canadian.

A tightknit Chinese community lived briefly in Stillwater. In the 1870s and 1880s, after the anti-Chinese legislation, the single men fled east from the American West. In Minnesota, they were entrepreneurs in the only occupations open to them: laundries and, later, restaurants. Approximately one hundred Chinese lived in the state: St. Paul, Duluth and Minneapolis had the largest populations.

Before World War II, 80 percent of American Chinese were from Guangdong (Canton) Province. Chinese were .002 percent of the U.S. population in 1880. In 1882, Congress passed the Chinese Exclusionary Act, and numbers further declined. However, in Minnesota, Chinese Americans escaped the intolerance of the American West. Sarah R. Mason in *They Chose Minnesota* said, "By 1885 there were 25 Chinese laundries in the capital city, 14 in Minneapolis, five in Duluth, and two in Stillwater." Again, Mason wrote that, from 1876 to 1910, "In Stillwater four laundries were

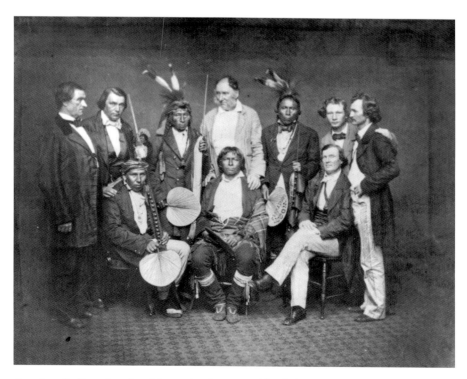

American Indians signed unfair treaties that opened lands for European settlement. *The St. Croix Collection.*

opened at various times during the early period on Chestnut and 2nd streets, close to the main business district."

Immigrants mixed with the old stock eastern businessmen and workers. Together, they developed Stillwater's diverse economy and civic institutions—a legacy that continues today.

BUILDING STILLWATER

*The period…is one of remarkable transitions, and, reaching backward, in the
liberty accorded to the historian, to the time of the first explorations by the Jesuits,
the first English, French and American traders, is a period of transformation
and progress that has not been paralleled only on the shores of the New World.
We have the transition from barbarism to civilization; we have the subjugation
of the wilderness by the first settlers; the organization of territorial and state
governments; an era of progress from the rude habits of the pioneer and trapper, to
the culture and refinement of civilized states.*
—*William H.C. Folsom,* Fifty Years in the Northwest

Folsom spoke with contemporary prejudices and keen insight into the
creation of Stillwater. After American Indians were decimated by
diseases, warfare or sent to reservations, eastern boosters' capital filled the
mythical void. "Civilization" was imposed on Stillwater, but not without a
massive influx of labor. Immigrants and employers reconstituted institutions,
including churches, schools, newspapers and hospitals—everything a
burgeoning city required.

Stillwater was constructed on Zion's Hill. There, overlooking the city, the
foundation was firmly established: the Washington County seat, the public
schools and churches.

Before the Panic of 1857, Socrates Nelson and Levi Churchill developed
Zion's Hill. Few lots were sold, and the situation worsened. In "The East
Half of the Churchill, Nelson and Slaughter Addition," Empson wrote:

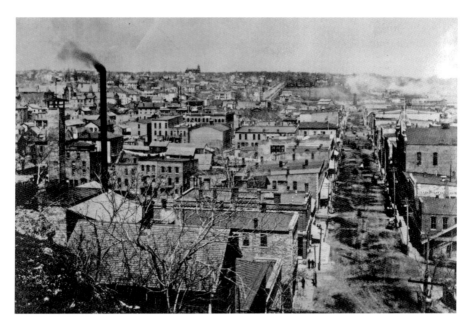

This 1880 bird's-eye view shows Stillwater, the thriving lumber city. *The St. Croix Collection.*

But as the economy collapsed, and the real estate market withered, Nelson, as the partner resident in Stillwater, realized the sale of his lots would ultimately depend upon better access to the top of the South Hill. To promote his property, Nelson did what many other land developers and speculators did in the nineteenth (and twentieth) centuries: they donated…a whole block for the building of a new Washington County Courthouse on Pine and South Third Streets.

City street improvements were required. The partnership between the city and developers benefited both parties. Empson continued:

As Churchill and Nelson anticipated, the building of the new Courthouse served as the impetus for other development. A new, large, and very grand public school, Central School, was constructed kitty-corner from the Courthouse and across South Third Street, Father Michael Murphy paid the astronomical sum of $4,000, in 1871 for three of the best lots and a house in the city on which he built the new St. Michael's Church.

Plans were realized, but neither man witnessed their shared vision: Churchill died in St. Louis in 1857, followed by Nelson after the groundbreaking on May 6, 1867.

However, Zion's Hill's impact was pivotal to the growth of the city. When South Third Street between Chestnut and Willard Streets was graded and the ravine filled, transportation was transformed. Before 1870, the South Hill was inaccessible from downtown except by the Main Street steps or a serpentine path to Nelson Street. In 1867, construction on the Washington County Courthouse and new high school commenced. The land had been deeded by Socrates and Betsey D. Nelson and Elizabeth M. Churchill—city block No. 36 for five dollars on April 12, 1867. The site was selected over a downtown location at Myrtle, Chestnut, Second Streets and Union Place. John McKusick had "insisted on a contract with certain restrictions and binding clauses," Dunn said in "Minnesota's Oldest Courthouse."

The courthouse combined elements of Greek Revival and Italianate architecture. St. Paul's first resident architect, Augustus F. Knight, received $976.26 for his plans. G.M. Seymour and William M. May's construction costs totaled $55,257.00. The January 1870 grand opening showcased a twelve- by eighteen-foot vestibule and a forty-six- by twelve-foot hall—the majestic cupola cost $3,000.00 alone. It replaced the three-room frame second courthouse at Fourth and Chestnut Streets constructed in 1847 and completed for $3,600.00 in 1849.

CHURCHES

Missionaries proselytized in the St. Croix Valley. Following permanent settlement in the 1850s, churches organized overnight into six parishes. The number had swelled to sixteen in fifteen buildings by 1888.

Several denominations traversed the region before the first services at Tamarack House in 1842. In "First Presbyterian Church of Stillwater," Diane Thompson wrote of William Boutwell, "In the summer of 1844, this explorer-missionary had added new dimension to the life of the villagers when he conducted a Sunday service in the dining room of Cornelius Lyman's boarding house." On alternate Sundays, he also preached at lumber camps in Stillwater, Marine and at Anson Northrup's hotel.

First Presbyterian Church was founded on December 8, 1849, with seven charter members, including William Holcombe, Ebenezer Cotton and Cornelius Lyman. Reverend J.C. Whitney graduated from Union

Theological Seminary on October 4, 1849. He began services at a school at Third and Olive Streets, with the assistance of Boutwell and Reverend Edward D. Neill. Henry Nichols was the first regular pastor in 1853.

Presbyterians were split between the "Old School"—more conservative version—and "New School" theology of Jonathan Edwards' reconstructed Puritan Calvinism. This schism resulted in the creation of Second Presbyterian Church in December 1853, known as "the Holcombe Church." Reverend J.C. Caldwell became pastor in 1856. Reverend J.S. Howell, formerly at Second Presbyterian, moved to First Presbyterian in 1862. Then, five years later, Reverend Edward B. Wright ministered at First Presbyterian.

Across the United States, "pew rents" were a divisive issue after the 1840s. Since, unlike in Europe, tithing was not state-sanctioned, families and individuals paid for assigned pews in many Catholic, Episcopalian and Presbyterian parishes. At First Presbyterian, during hard financial times, rents increased by five dollars in one year to service debt.

First Presbyterian Church, constructed in 1851, was replaced within six years by a second church at Third and Myrtle Streets. The *Messenger* article "The New Church," of September 22, 1857, said, "The new edifice for the 1st Presbyterian Society of this city is now raised, and the work progressing as rapidly as the weather will admit." The city purchased the church. Relocating the building across the street to the present site of the Post Office, it was converted into an armory. The new church was constructed in 1884 at Myrtle and Third Streets at a cost of $22,000. An annex was added in 1924.

In 1968, construction began on the present church, at 6201 Osgood Avenue. The church bell was donated by Isaac Staples in 1869. The $500,000 project was dedicated on December 5, 1971. Dick Nelson of Marine purchased the *old* church, later transformed into the ten-unit Steeple Town Condominiums.

Ascension (Episcopal) Church began in 1838. Reverend E.A. Greenleaf was the first regular minister; he preached at the first postmaster Elam Greeley's house on Main Street in 1846. He also officiated the first marriage "uniting John McKusick, still a respected citizen of this city, and Miss Phebe D. Greeley," said Warner and Foote. In 1851, a cornerstone was laid. The church was consecrated in 1853, but as the flock grew, the building became inadequate. In 1873, Bishop Welles of Wisconsin laid the cornerstone, but the $100,000 church burned down in 1886. The church was rebuilt in 1887—and remains on North Fourth Street.

The Methodist Episcopalian Church organized in 1850. The Ohio Conference arrived in Minnesota in 1824. Missionaries entered the region

in 1830, for example, Reverend Henry Brace of the St. Croix Mission from "Rock River Conference of the Methodist Episcopal Church" in Platteville, Wisconsin. Brace preached from Lake Pepin to St. Croix Falls in 1841 but never conducted church services. Reverend J.W. Putnam was the first missionary in 1845 to 1846 from Illinois. The Minnesota Conference formed at Stillwater within the St. Paul District in 1856. The first Methodist Episcopalian Church was a modest structure: costing $1,332 with "unseasoned"—or uncured, lumber. The second church (October 2, 1870) was located at North Third Street. The parish flourished, swelling from twenty-eight (1869) to two hundred members (1888).

In 1870, the Swedish Methodist Church began in Stillwater. Reverend C.S. Carlander preached when Swedish language and culture were essential. But Swedish-ness faded with Americanization, attendance dropped, and parishioners aged, leading the two Methodist churches to merge in 1945. In 1955, the church purchased the Greeley mansion, and a new church (813 West Myrtle Street) was completed in 1960.

The Universalist Church was once a thriving denomination in Stillwater. Reverend E.A. Hodson (also of St. Anthony) conducted the first services in 1852. The *Stillwater Democrat* reported that W.W. King held services at the courthouse rather than Holcombe Hall (December 3, 1859). The turnover of ministers continued when Oliver Parsons (June 1, 1861) led twenty-five members. In the 1880s, Roney said, the Universalists "erected an imposing edifice with a tall spire on the west side of Third between Oak and Pine." Later, it was acquired by the school district and converted into the Activities building. By 1909, Easton wrote, "No regular services have been held…for many years."

Throughout America, ethnic churches linked immigrants to the old country and their new homeland. Stillwater was no exception. Germans, Swedes, Norwegians and Danes founded various Protestant parishes. Folsom mentioned the Danish Lutheran Church (a $7,000 edifice at Owens Street), Swedish Congregational (Fourth Street between Hickory and Elm Streets, $2,000) with 60 members and the Swedish Episcopalian Church. The German Lutheran Church organized in 1871 and had a joint arrangement with the Norwegian Lutheran Church. The Swedish Lutheran Church was constructed slowly but was finally completed in 1882–83; Reverend A.F. Tornell led the 217 members in 1881.

Our Savior's Lutheran Church began in 1858. Originally named the Norwegian Church of Stillwater, a small group of Norwegian immigrants shared pastors with Bayport and Hudson, Wisconsin. Funds were raised

To accommodate settlers, a church row developed on Third Street. *Sherman Wick.*

In 1858, Norwegian immigrants organized Our Savior's Lutheran Church, now located on eleven acres west of downtown Stillwater. *Sherman Wick.*

for a church, while services were held in homes—a common practice for working-class immigrants in the late 1880s. *The Settlers* described this practice in fiction. Swedish immigrant farmers near Chisago Lake met "every Sunday at each house in turn to enjoy the comfort of religion and help each other with matters." The old church was on Myrtle Street. The current church is on Olive Street (1960), an eleven-acre site completed in 1961 with additions in 1988 and 2003.

St. Michael's Catholic Church originated as a Roman Catholic territorial parish in the diocese of St. Paul and, later, the Archdiocese of St. Paul and Minneapolis. The initial congregation was largely French Canadian fur traders, but Irish soon dominated the church.

In private homes, Fathers Peyragrosse and Ravoux performed Mass between 1849 and 1853. Bishop Cretin visited his flock in 1852; however, in 1853, Father Daniel J. Fisher organized the church (Fourth and Mulberry Streets) before accepting the presidency of Seton Hall College in New Jersey in 1856.

Maurice Murphy was St. Michael's visionary. After he arrived in 1870, fundraising commenced for the new church. The *Gazette* described "The Catholic Fair" of July 2, 1872, held at Mammoth Hall in the "new" Hersey

and Staples block on Main Street. Projected daily attendance was five hundred persons for Monday, seven hundred for Tuesday, and one thousand on Wednesday. Guests were fêted with "ice cream, strawberries, lemonade, oysters, roast turkey, chickens." The *Stillwater Messenger* of July 12, 1872, reported a few hundred dollars of expenses, while earnings exceeded $5,000.

The church was capped with a 180-foot spire. Architect E.P. Bassford of St. Paul created the Romanesque and Gothic roof with native stone and Kasota trimming on Third Street. J. O'Shaughnessy received the $50,000 construction bid. The Society of St. Vincent reserved the basement. The *Messenger* reported on the "New Catholic Church" on May 24, 1872, saying that the church would be "a magnificent and imposing building, a pride to the city and one of the finest, neatest and most elegant in the State." Construction began in 1872 and was completed in 1875. Bishop Thomas Grace dedicated the church on August 15.

The editors of *History of Washington County*, George Warner and Charles M. Foote, said, "The congregation is evidently the largest in the city." Christmas services illustrated the church's success. The *Gazette* reported on December 26, 1889: "Five masses were celebrated, the first one, at which Father Murphy officiated and preached, being at five o'clock in the morning. The altars and sanctuary were elaborately and tastefully decorated with flowers and evergreens, while an array of waxen tapers, shedding their mellow light on the sacred surroundings."

After Murphy resigned in 1891, leadership longevity continued with Reverend Charles Corcoran, who served until his death in 1943. He shepherded the church's continued growth, the *Gazette* reported on May 17, 1899: two hundred boys and girls were confirmed. By 1906, there were "1,500 communicants" and 200 children educated by Sisters of St. Joseph.

St. Charles Catholic Church was a necessary extension of St. Michael's. Father Corcoran monopolized Catholics during his lifetime; then, Archbishop John G. Murray permitted the new Bayport parish, dedicated in 1954.

St. Mary's Catholic Church organized twelve years after St. Michael's. Newly ordained priest Aloysius Plut was the first pastor. Germans and Swiss started Immaculate Conception Catholic Church on February 15, 1865, and worshipped in a former Presbyterian church (Third and Chestnut Streets). The church relocated to Fifth Street near Pine in 1871, and a "German Catholic school" was created with instructors from St. Joseph Sisters and the financial assistance of Joseph Wolf. By 1880, the sisters of St. John's Abbey (Benedictine Order) at Collegeville provided

teachers. The following year, Reverend Willebrod Mahowald served sixty families. In 1884, Bishop John Ireland consecrated the church, which had 115 German families and 80 schoolchildren by 1892. Conzen, in *Germans in Minnesota*, described the parishes in Minnesota, "By 1892, Minnesota had 182 parishes and missions that were served by 150 German-speaking priests, 56 of them Benedictines."

St. Joseph's was the third Catholic Church parish. The national church was primarily composed of French Canadian—and later, Italian—Catholics. Father E. Roe led the seventeen-member church in 1882. Lots were purchased on Olive and Greeley Streets for $8,000 and seated four hundred in 1883. Years later, the *Gazette* announced Reverend A.M. Vanden Bosch's retirement after preaching for nineteen years. He returned to live with his brothers in Belgium a year before World War I. The church disbanded in the 1950s.

St. John's Evangelical Lutheran Church began in 1851. Pastor Father Wilhelm Wier arrived from St. Paul on horseback. The first Lutheran sermon in Washington County was preached in Albert Boese's home on August 17, 1855. Wier insisted on "private confession," but parishioners were accustomed to "common confession," and the church divided.

In Baytown, two acres were purchased. Weekly services were conducted in German—on alternate weeks, once a month and, finally, only during festivals. Today, the original St. John's Lutheran is incorporated in the Parish Hall.

St. Paul's Lutheran Church and St. John's Evangelical Lutheran share their early histories. From its inception as St. Paul's German, Reverend Hoffman of Lake Elmo led the early church in 1865.

Without an altar or pulpit, Reverend Jacob J. Siegrist founded the church in 1870. The simple wooden structure was located at Third and Olive Streets in 1871. Siegrist severed ties with the Wisconsin Synod over doctrinal issues in 1882. "The Siegrist faction" fought the "Synodical faction." Siegrist interpreted the Calvinist predestination and election doctrines in opposition to common church practices. He remained with Minnesota Synod and Salem Lutheran Congregation in Stillwater, transferring to Green Bay in 1883. Reverend Philip Mueller replaced him.

In 1894, the church moved to Myrtle and Martha Streets. Reverend A.C. Ernst led another church, dedicated on September 12, 1912. In 1950, ground was broken at 609 South Fifth Street, and a new church was dedicated in 1952. The church cost an estimated $150,000, measured 108 feet long by 40 feet wide and seated 350 parishioners. At the third church, in 1953, Ernst continued as pastor emeritus.

Joe Perro and Ambrose Secrest donated (or sold) the land for Hazlewood Cemetery. *Sherman Wick.*

Salem Lutheran Church began on September 12, 1882. The congregation purchased a Swedish church at Fourth and Oak Streets. In 1882, the church was also embroiled in a predestination controversy. New church plans were made in 1960, and a new building was dedicated on Sixty-Second Street on May 19, 1963.

Stillwater's first burial ground was "block three" of the original plat; according to Roney, there were also two or three pioneer cemeteries.

Adjacent to Hazelwood Cemetery, St. Michael's Catholic Cemetery is maintained by the City of Bayport. Ambrose Secrest and Joe Perro purchased and donated the northwest portion of Baytown in 1858. Hazelwood and St. Michael's Cemetery share adjacent sites—the latter is to the north and paved.

The Fairview Cemetery Association formed in 1867. The nondenominational cemetery at Orleans and Fourth Streets also contains bodies moved from county cemeteries. The association included a post–Civil War Stillwater who's-who: Isaac Staples, David Bronson, Samuel Register (riverboat captain), Andrew J. Van Vorhes and George M. Seymour. William B. Palmer sold the land for $900, with an additional $1,140 for the sexton's fence and house. Cemetery squatters—illegally buried deceased—were an early problem.

STILLWATER PUBLIC SCHOOLS

Warner and Foote wrote, "The dawn of educational enterprise in this city was seen in the little school taught in 1846 by Mrs. Sarah L. Judd." After she married, Mrs. Ariel Eldridge taught nine pupils in a vacant lot on Union Alley. The class was composed of "two children of Carli, three of Anson Northrup, two of Lyman, one of Carmody, and a French girl whose name does not appear." During the second term, the summer of 1847, Mrs. Greenleaf was the teacher. In 1848, there was a school between Second, Third and Olive Streets.

In *Concise History of the State of Minnesota*, Neill writes, "In Stillwater there had been schools for a brief period, in private houses, until 1848, when Amanda M. Hosford arrived under the auspices of the same Educational Society as the teacher in St. Paul, and in 1849, a Miss Backus…at the Falls of St. Anthony."

The *Stillwater Democrat* reported a "School Notice" on April 30, 1859: "The Spring term of the Common Schools of the city of Stillwater will commence on Monday the second day of May next." The article continued, "Miss Wilson's School will attend at Pugsley's Hall and Miss Mower's at Wm. M. McKusick's building…on Union Street." Mahlon Black and William M. McKusick were trustees.

The territorial legislature organized Stillwater District No. 1 in 1850; in 1862, it became No. 9. In 1864, the county school system was reorganized, and it lasted until the surrounding school districts were consolidated in 1954. The School Reorganization Act of 1947 resulted in a special election, and consolidated Stillwater (9), Bayport (15), Lake Elmo (17), Oak Park (14), Lakeland (21), plus more than a dozen districts in August 1953. The school districts were combined into District 834, the largest in Washington County.

The Schulenburg School (Second and Hazel Streets) was constructed in the late 1860s for $2,700 and opened in the early 1870s. Schools enrolled first through eighth grade, but Schulenburg had only the "lower grades." The school closed in 1937 and was a community center until burning down.

In 1869, the Central School building was erected on Zion's Hill between Pine and Third Streets. The three-story building, equipped with steam heating and "school-room furniture," totaled $45,000 with the add-ons. The rooms (twenty-four by thirty-four feet) included blackboards and a closet. Razed in 1937, a new junior high was constructed the next year.

In 1873, Lincoln School, the first public high school, was built on Government Hill between Third and Fourth Streets. The three-story

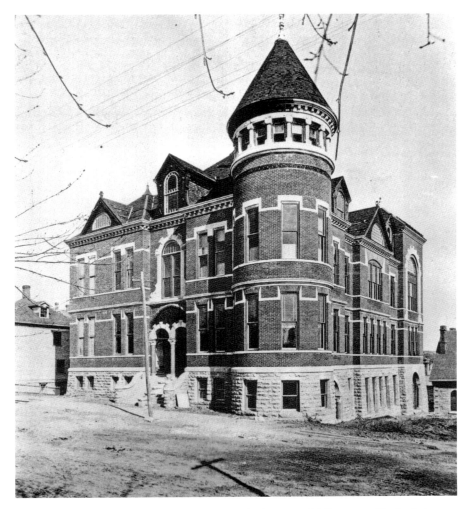

Stillwater High was one of the first high schools in the state of Minnesota. *The St. Croix Collection.*

building (fifty-five by ninety-five feet) cost $35,000 to construct but, with additional technology, amounted to $45,000. In 1876, Herbert N. McKusick was the only graduate on June 2. Today, the Lincoln School bell is at the Stillwater Area High School in Oak Park Heights.

The Greeley School, located on Greeley Street, was constructed in 1875 and later razed. Today, homes are on the site.

The Nelson School (1018 South First Street) was constructed in 1897. Named after Socrates Nelson, the Neoclassical and Georgian Revival

building was later renovated by River Town Restoration (RTR). In 1979, it was listed in the National Register of Historic Places.

The ups and downs of the city correspond with enrollment in Stillwater schools. There were 937 students on March 30, 1879. By 1888, the *Gazette* was reporting 1,564 students. Student enrollment anticipated future population demographics in Minnesota: Minneapolis (19,196 students), St. Paul (13,528), Red Wing (1,352), Mankato (1,354) and Stillwater (1,672) as of July 31, 1889.

Student capacity and construction costs for Stillwater Public Schools in 1888 were as follows: high school, 300, $42,000; Lincoln School, 700, $55,000; Central School, 550, $35,000; Garfield, 130, $6,000; Greeley, 100, $4,000; Nelson, 100, $4,000; and Schulenburg, 100, $2,500.

Stillwater High School was constructed on South Hill (Pine and Third Streets) in 1887. The high school enrolled two hundred students in 1900 but lacked a junior high, hot lunch or music and band instruction. In 1923, the school received a gymnasium when lumber baron Fred W. Tozer donated $75,000.

The Stillwater High School fire occurred on December 23, 1957, at 6:00 p.m. The *Gazette* reported a $250,000 loss. Lost were four classrooms: a

Built in 1897, Nelson School was a neighborhood school that was later converted into condominiums. *Sherman Wick.*

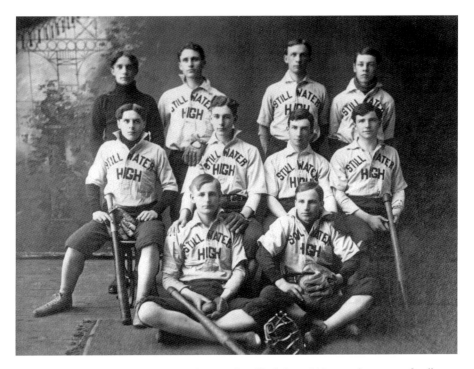

As industry declined, sports were an element that filled the void in creating a new, family-friendly image for Stillwater. *The St. Croix Collection.*

band room, a music room, the principal's office and the library. The coup de grâce: the Stillwater Fire Department's 1914 American France Pumper was decommissioned after the fire. The next day, the *Gazette* continued, "Captain Bill Hering Jr. and his men protected homes and the Junior high school nearby."

A new Stillwater High School opened in 1960 (523 West Marsh Street). Finally, the newest Stillwater Area High School debuted on a 139-acre site in Oak Park Heights in 1993.

Until the 1960s, Stillwater schools were incongruent with the "normal" schools in the state. Dave Kenney said, in *Minnesota in the '70s*, "Until the mid 1960s, most elementary schools in Minnesota were rural, one-room schoolhouses. In 1971 the state legislature approved a new law requiring all schools to consolidate into districts offering full programming for grades one through twelve." There were five hundred rural schools in the spring of 1970; the new state law was enforced on July 1, 1971. One example, the Hay Lake School, near Scandia (1895), closed on July 1, 1970.

STILLWATER LIBRARY

The first Stillwater library was private; books were borrowed for fees. E.S. Dodge established a circulating library at the Pioneer Book Store. The proto-public library predated the Stillwater Library Association.

The Stillwater public library gained impetus in 1859. U.S. senator Henry M. Rice recommended a library association for storing government documents. William M. Mcluer, Hollis Murdock and others organized a permanent home. Roney said, "As the books and documents piled up, they were stored in various places about town, even including the jail." The Stillwater Library Association organized at the board of education offices (Main and Myrtle Streets) in 1859 and quickly contained 1,600 volumes.

Prominent local women promoted a permanent library. Mrs. Charles Hempstead, Mrs. W.G. Bronson, Mrs. Helen M. Torinus and Mrs. William Mcluer canvassed for donations: fifty cents for women and one dollar for men. The library moved from various downtown locations. In the 1890s, Mrs. Elmira Treat served the free library on the second floor on North Main and Myrtle Streets. Library patrons paid rental fees for books.

City voters ratified by 66 percent a free public library on November 2, 1897. Within five years, Stillwater received a grant for a Carnegie library. In *Carnegie Libraries of Minnesota*, Kevin Clemens wrote, "Between 1893 when the first Carnegie Library was built in Fairfield, Iowa, and 1919 when the last was built in American Fork, Utah, the American industrialist provided a total of $41,748,689 in grants to build 1,689 libraries in the United States." In Minnesota, sixty-five public libraries and one private library (Hamline University) were constructed. A permanent library site was required to receive a grant. After Carnegie sold his ironworks to U.S. Steel Corp., S. Blair Mc Beath asked him for a grant. Stillwater, Mankato, Duluth and St. Cloud were the first recipients in the state. Carnegie donated $27,500 for a public library in 1901, designed by Patton and Miller of Chicago. The Classical Revival Stillwater Library opened in 1902.

The Stillwater Library expanded over decades. In the 1960s, the bookmobile was an essential modern amenity. The *St. Paul Dispatch* of April 9, 1963, reported, "New Bookmobile Triples Capacity of Old Vehicle." The library renovation began; two symmetrical wings on the north and south doubled the floor space by 1973. Handicap access was added in 1986. Finally, a parking ramp included "community space," a terrace and gallery for art in 2003–06.

The library established a rare books collection on May 2, 1964. The St. Croix Collection has had several names, including the Minnesota Room, dedicated by state representative Gary Laidig in 1974.

NEWSPAPERS

The first Stillwater newspaper was issued five years after Minnesota Territory was established. Eastern and in-state papers embellished the region's attributes even before then. James Madison Goodhue promoted "the lakes," "climate" and "pure lumber." In the *Minnesota Pioneer* of May 5, 1849, he described the Falls of St. Anthony, Bass Lake (six miles from Stillwater on the St. Paul road) and Stillwater thusly: "This charming village in the lap of an amphitheatre of hills, on the western shore of the St. Croix Lake." George S. Hage said, in *Newspapers on the Minnesota Frontier,* about the first paper in the state, "Week after week Goodhue's leading article in the *Pioneer* would run through two, three, four columns of solid type describing for eastern eyes what he had observed. Stillwater and the St. Croix River, the settlements of St. Anthony, Mendota, Red Rock, and Cottage Grove, the lakes of White Bear and Bald Eagle, Fort Snelling and the military reserve—all these and more he surveyed with imagination and a sharp eye for detail." Daniel Boorstin described the role of the press as civic boosters: "The first issue of Ignatius Donnelly's *Emigrant Aid Journal* (1856), which urged the nonpareil virtues of the city of Nininger (still to be constructed) in Minnesota, was actually published out of Philadelphia."

There was no shortage of journalistic competition in Stillwater. Boorstin said, "In Minnesota, for example, by the end of 1857 (a year before statehood), there were printing offices in over forty towns and villages, many of them publishing newspapers." The booster press was instrumental in attracting eastern

Newspaper editor James Madison Goodhue promoted Stillwater's interest to eastern investors and settlers. *The St. Croix Collection.*

capital and settlers. He continued, "newspapers in the upstart West often began publication before the cities existed to support them and their editors wrote copy under elm trees and issued papers from log-cabins, so hotels sprang up in lonely woods or cornfields." On June 3, 1858, the first newspaper convention in Minnesota was held in St. Paul, with thirteen men from twelve newspapers in attendance. Columbus Stebbins of the *Hastings Independent* was elected president, while Frank Sommers of the *St. Paul Pioneer* and Andrew J. Van Vorhes of the *Stillwater Messenger* were vice-presidents.

The *St. Croix Union* became the first newspaper in Stillwater and Washington County, and the thirteenth newspaper in Minnesota, on October 23, 1854. F.S. Cable and Wilder Easton of Ohio published the four-page, seven-column weekly. Prominent Democrats, including Lieutenant Governor William Holcombe, invested $1,000 in capital. M.H. Abbott and W.M. Easton succeeded Cable. Early articles included adventure stories, such as "Daniel Boone," "Recent Progress of the Mormons" and "Night Ride on a Locomotive."

The *St. Croix Union* advocated for Stillwater, stating, on October 23, 1854, "This village, located at the head of Lake St. Croix, possessed many advantages which must inevitably aid in building it up, and giving it a place of no mean importance" and continued:

> *The permanent inhabitants, now numbering nearly 2,000, are intelligent and industrious. Churches and schools are liberally supported, and I am glad to add that the Press—The engine of power, the People's library of useful knowledge—has also its advocates and supporters. They are about starting two weekly papers here, one of which I understand will go into operation on Monday next.*

Daniel S.B. Johnston commented in a *Minnesota History* article, "Nearly every issue of his paper had crisp editorials on the advantages possessed by Minnesota."

Regardless of quality, the paper ended on November 13, 1857.

Briefly published in 1855, *Rube's Advocate* collected satirical comic stories, poems and fake ads. The paper wrote on January 1, 1855, "This Territory is made up of many political parties and factions—in all these I have numerous friends, and I claim a majority. If I am correct in my views with regard to my political strength, I will stand the best chance to be elected Territorial printer." The quote captured the paper's unfettered and jocular tone.

The *Stillwater Messenger* was a staunchly Republican newspaper. The copy reflected a partisan perspective. For example, when the Civil War began, the editor supported the Union by enlisting.

In 1855, Andrew J. Van Vorhes arrived in Stillwater. Van Vorhes was born in Washington County, Pennsylvania, on June 30, 1824, the son of a newspaperman. At thirteen years old, according to Daniel Johnston, "he began to set type on his father's paper," the *Hocking Valley Gazette*. His brother, Nelson, changed the paper's name to the *Athens Messenger*—hence, his attachment to "Messenger." Andrew was elected to the Minnesota legislature in 1860, when the Civil War was inevitable.

The *Stillwater Messenger* office was established on Third and Chestnut Streets in 1856. The four-page, seven-column paper moved to Main Street on the second floor of the Bernheimer block. The paper's Republican position was conveyed with such articles as, on September 22, 1857, "What Slavery Has Done for the United States." The paper said, "It has developed a spirit of aristocracy in the nation and brought honest free labor into contempt." But in the same issue, the paper's crystal ball was murkier: "Marine Mills is the name of one of the oldest settlements in Minnesota, and is destined to rank among the principal manufacturing points in the Territory." Partisan distrust is nothing new to politics. The Stillwater Republican and Democrat newspapers battled on October 13, 1857, with the stentorian headline: "Look Out! Look Out!! Fraud and Deception Contemplated." The *Messenger* stated, "We warn you that some damnable game of deception is contemplated to-morrow. The St. Croix Union, whose publication day is Friday, is not yet circulating at noon on Monday!" He continued, "Some outrageous libel upon the Republican party will be circulated on the morning of the election, too late for refutation." Then, with xenophobia, the paper paternalistically opined, "Germans and Irishmen! This game is designed to impose upon you."

During the Civil War, Van Vorhes served as a quartermaster (1863–65). The paper was leased by A.B. Easton and A.B. Stickney (future president of the Chicago Great Western Railway Company). Van Vorhes returned, but ownership changes continued. Before the presidential election on March 11, 1868, Willard S. Whitmore purchased the *Messenger,* and the paper was rechristened the *Stillwater Republican* until October 4, 1870. George K. Shaw of Minneapolis purchased the paper, and the name reverted to the *Stillwater Messenger* (or *Stillwater Messenger No. 2* on December 16, 1870). A.J. Van Vorhes died in Stillwater on January 10, 1873.

On October 11, 1892, *Stillwater Messenger* editor Victor C. Seward was shot and killed by a mentally ill twenty-three-year-old former employee, George

The *Gazette* has served the city continuously since 1870. *Sherman Wick.*

Peters. Under various names, mergers and managements, the *Messenger* continued. Billed as the *Post-Messenger* in the late 1940s, the paper evolved into the *Stillwater News*.

The *Stillwater Gazette* has reported the news since August 6, 1870. Augustus B. Easton arrived from Ohio. He was a man of acknowledged "Puritan stock," reflected in the incisive copy of the paper. The eight-column paper covered national and local news. In 1876, Will Easton was elevated to equal partner. After purchasing a steam-powered press in 1879, Easton enlarged to nine columns and accepted "job printing." The paper was sold to S.A. Clewell on January 1, 1883. Subscriptions were fifty cents per month and one dollar for an entire year in 1888. The paper republished *Prison Mirror* articles in the 1890s, including "A Historical Sketch" of prisons. In 1896, Clewell sold to W.C. Masterman.

The *Stillwater Democrat* was a six-column weekly paper. It featured local, national and international news and was published by L.F. Spalding and C.P. Lane. First issued in December 1858, the paper featured Democratic Party news and ads. Unlike partisan news today, the paper showed remarkable restraint and respect during the March 7, 1889 inauguration, saying Democratic president Grover Cleveland

> *stepped down and out from the chair which he has dignified and honored for the past four years and Benjamin Harrison the 26th president assumed his place. While the* DEMOCRAT *opposed the election of the latter it joins with all good citizens in honoring and respecting the chief magistrate of this great nation.*

In contrast, in antebellum Minnesota, the paper railed with racism in a piece titled, "Fugitive Slaves on the Backtrack" (August 20, 1859):

Becoming weary of Canadian freedom, which to many blacks embraces the exalted liberty of going inadequately clothed and of being nearly starved to death, they were about to return to the South, preferring plantation life to the responsibilities attended on a state of existence for which circumstances have rendered them peculiarly disqualified.

Later editions competed for readers and concentrated on the constellation of communities around Stillwater, South Stillwater, Houlton, Oak Park and Lake Elmo.

The *Stillwater Lumberman* was published under various names but remained quirkily informative. Edwin H. Folsom dedicated newspaper coverage to the lumber industry on April 9, 1875. And on May 2, 1875, it reported, "Durant, Wheeler, & Co. sold four strings of logs, to Dickerson & Mack." Detailed were sales by firms in each issue, for example, Bronson & Folsom and J.S. Anderson. In 1876, S.A. Clewell and H.A. Taylor assumed ownership of the paper; however, within a year, Taylor relinquished his financial position. The newspaper relocated from the Mower to the Bernheimer block. The revolving-door ownership continued; E.A. Taylor became a financial backer in 1878.

Warner and Foote said, "The *Lumberman* newspaper is widely circulated among the best class of readers in the St. Croix valley." In 1887, during the apex of the lumber industry, J. Newton Nind was editor. Thereafter, the paper's name changed a couple of times before it moved to Minneapolis.

The *Daily Sun*, or *Stillwater Sun Daily*, was an "offshoot of the Lumberman," said Easton. The paper's tone was sensationalistic and gossipy, with neighborhood news—and daily cause célèbre updates: for example, ongoing stories about Charles Guiteau, President James A. Garfield's assassin.

The *Sun* began when Joseph Pulitzer and his more sensationalistic foe, William Randolph Hearst, created yellow journalism. Pulitzer purchased the *New York World* in 1883, and circulation improved fivefold. By the late 1890s, it increased to over one million. In *A Short History of the American Nation*, John A. Garraty and Mark C. Carnes wrote:

Pulitzer achieved this brilliant success by casting a wide net. To the masses he offered bold black headlines devoted to crime (ANOTHER MURDERER TO HANG), scandal (VICE ADMIRAL'S SON IN JAIL), catastrophe (TWENTY FOUR MINERS KILLED), society and the theater (LILY LANGTRY'S NEW ADMIRER), together with feature stories, political cartoons, sports pages, comics, and pictures. For the educated and affluent

he provided better political and financial coverage than the most respectable New York journals.

F.C. Neumeier published *Washington County Journal*, an "independent and impartial" newspaper, beginning on March 4, 1893. The weekly eight-page, six-column paper also employed Hearst's methods, focusing on quirky proto-news stories: "New Arrivals at Prison" and "News Gathered during the Week."

Stillwater mirrored cities throughout the state and nation by having foreign-language newspapers. W.P. Schilling & Company established the German-language *St. Croix Post* in 1876. Later, William Schermuly issued the six-column paper from the *Gazette*'s office. Franz (Frank) Aiple and Joseph Wolf's Empire Brewer advertised alongside German doctors and Erste (German for "first") First National Bank, written in German Gothic font. Julius Duel edited the German-language *St. Croix Post*'s weekly magazine supplement, *Der Erzähler* (1882–90). Frederick Neumeier printed various German language and English newspapers from the 1870s until he died in 1927. The paper underwent several ownership changes, but as Warner and Foote said, it "reaches every German home in the St. Croix valley." Neumeier published *Der Hermanns Sohn Im Westen* from 1891 to 1897 and in 1910. This was the Sons of Hermann organizational newspaper, intended for the entire United States.

The local Scandinavian community also had a newspaper: *Vesterlandet* (the Western Lands). L.E. Olson edited the Swedish-language weekly, printed in the 1890s.

The *Prison Mirror* newspaper is internationally acclaimed, edited and printed by inmates. William C. Heilbron said, in *Convict Life at the Minnesota State Prison*, "The *Prison Mirror*, with the exception of the *Summary*, published at the Elmira reformatory, is the oldest institutional paper in the country."

The first issue of the *Mirror* appeared on August 10, 1887. Released weekly on Wednesdays, it was funded by fifteen prisoners, including Cole Younger (twenty dollars), James Younger (twenty dollars) and Robert Younger (ten dollars). W.F. Mirick was the first editor. For the inaugural issue, Warden J.G. Stordock wrote on August 10, 1887:

> *It is with no little pride and pleasure that we present to you, kind reader...* THE PRISON MIRROR, *believing as we do that the introduction of the printing press into the great penal institutions of our land, is the first important step taken toward solving the great problem of true prison reform.*

It was his "untiring mission" for the penitentiary "to encourage prison literary talent." Stordock also wrote: "I am responsible for the venture. I hope and believe that a generous public will give the *MIRROR* all the encouragement that it shall deserve."

In the autobiographical *The Story of Cole Younger*, Younger said, "When H.G. Stordock became warden, I was made librarian, while Jim carried mail and Bob was clerk to the steward." Cole Younger continued, "Every one of the wardens was our friend." He earned the position through prison labor: he had made "buckets and tubs," worked at the thresher factory and, finally, became librarian.

The public responded favorably to the *Mirror*. The "Hon. W.R. Marshall," former governor and Civil War hero, lauded the paper on Wednesday, August 24, 1887. Notes of encouragement were received from numerous newspapers, including *Wilkin County Gazette*, *St. Peter Journal*, *Fargo Argus* and the *Minneapolis Evening Journal*.

The topics of articles varied, but prison reform was regularly addressed. Other features focused on "An analysis of Crime" and prison labor. Contemporary prison journals were also reprinted, such as the *Elmira Summary*. On August 22, 1888, "The New Prison Labor Law" wrote: "The whole question of convict employment has been put into a great muddle. The one clear and certain result of it will be a heavy and needless burden on the taxpayers" (reprinted from the *Elmira Summary*). The *Mirror* contained ads for Northwestern Manufacturing & Car Co., bakeries, clothiers, bookstores and other Stillwater businesses. In the second year, the paper earned $150 in profits.

The content of the *Mirror* evolved. In 1926, articles were signed with colorful aliases: "Clem," "Bubbles," "Mack," "Huck," "Finn," "Lud" and "Ringside." Columns featured were "Shop Notes," "Laundry Suds" and "Foundry Sparks." Important institutional and state news was also reported. The *Mirror* featured an article on July 17, 1987, "Stillwater Farm Equipment Too Competitive." It stated, "The Wisconsin Assembly has resisted a temptation to ban the sale in Wisconsin of farm equipment made at MCF-Stillwater." Around 1988, the "Industry Inmate of the Month" was a regular column, with a photograph and prison position. By the 2000s, the masthead of the three-column, newsletter-style monthly was festooned with the apropos, "It's Never Too Late to Mend," while informing the general public about the state prison.

The *Stillwater News* foreshadowed community newspapers. The masthead stated that it was established in 1900 in Stillwater as "a continuation of the

Trade News" and was owned and published by George W. Schuttinger until editor I.J. Daly took over in 1932. It was published every Friday with a focus on neighborhood news. Headlines from January 1, 1932, included "Oak Park Man Found Dead," "Wm. Retzlaff Passes Away at Hospital" and "Sewer Pipe Bids Received by the City." World news was also covered, for example, a brief jotting about Mahatma Gandhi. Bayport was a particular focus. The paper reported the town's social events, visitors, sojourns and gatherings; for example, "Mrs. V. Wick entertained friends at luncheon Monday."

The seven-column Thursday weekly *Bayport Herald* was another proto-neighborhood paper. Typical articles included Andersen Corporation earning $60,000 in profit-sharing (January 30, 1941); local sports, including boys' basketball and girls' skiing; and comics, ads and national news. Editor Ray A. Hannah also sold ads for the *Post-Messenger*.

Finally, the short-lived *Bayport Photo News* was a quirky neighborhood newspaper. University of Minnesota grads, editor Richard Luhman and ad salesman Don Larson, focused on the entire St. Croix Valley, with offices in Stillwater. Later, the paper's gaze shifted and concentrated on Bayport, Lake Elmo, Lakeland, St. Croix Beach and Afton. The paper appeared chintzy, but it was elevated by idiosyncratic stories. One example was the article "Thompson what? Bayport Noted for Nicknames" (June 30, 1965) by Carole Johnson: "It takes a keen sense of memory to live in Bayport." The *Bayport Almanac* recorded approximately four hundred nicknames: Eugene "Peanuts" Bell, Edward "Schnergy" Noreen and "Taterbug" Thompson. Others included "Tut," "Ham," "Muggie" and "Kook." Johnson concluded, "As I say, Bayport is much like any other town; It's just the people that are different."

SOCIAL AND FRATERNAL ORGANIZATIONS

Lodges were often reestablished in Stillwater from another city. The Freemasons organized at St. John's Lodge No. 1 on October 12, 1850. The city's first freemasons were from St. Paul and, originally, from the Grand Lodge of Ohio (August 4, 1849). F.K. Bartlett, William Holcombe and A. Van Vorhes were officers for the order that originated with the fourteenth-century stonemasons. In 1849, the Independent Order of Odd Fellowship formed; the deputy grand master was from Galena, Illinois. A paucity of active members closed the organization during the Civil War (1863). It reopened with a new charter on January 5, 1876.

Many early organizations are unheard of today. The Washington Royal Arch Chapter No. 17 organized on March 3, 1868. The Rebekahs were the Odd Fellows' women's division, whose "three link fraternity" included "friendship, love, and truth." The organization began in Britain, but it had arrived in the United States in 1819. The *Stillwater News* reported on the Odd Fellows almost weekly in the 1930s.

In 1917, the Lions formed in Chicago. The organization quickly grew—with sixty thousand national Lions Clubs members by 1927. The Stillwater chapter's first lunch was at the Lowell Inn on May 22, 1928; prominent lawyer Karl Neumeier presided and *Stillwater News* editor I.J. Daly served as an officer. Members underwent intense screening—Rotary

Stillwater fraternal organizations popularized the Lowell Inn as a perennial luncheon destination. *Sherman Wick.*

Club members were automatically excluded. In 1928, the annual fee was twelve dollars, but increased to one hundred dollars quarterly in 2007. Until the 1980s, weekly lunches and picnics were exclusively male. Pamela Schultz and Esther Tomaljanovich received membership; the latter was a pioneering attorney appointed to the Washington County District Court in 1978 and to the state Supreme Court in 1990.

Recently, the Stillwater Rotary Club's president was a Lions Club member, John Rheinberger. The organizations began as competitors, with an annual kitten-ball game in 1928. Paul P. Harris, a Chicago attorney, organized the Rotarians in 1905. Hank Sampson wrote in *50th Anniversary: This Is Your Life: The Stillwater Rotary Club, 1919–1969* that the organization started when "community life was at a low ebb." The first meeting was held in the Comfort & Comfort law offices, with George V. Bancroft presiding. The first civic cause was a Lily Lake bathhouse. The organization hosted various lunch speakers; occasionally, they were community business trailblazers. For example, Chester S. Wilson, the state conservation director, spoke in February 1948. He discussed restoring natural resources and recommended investing more in order to exceed the current "only about one-tenth of what

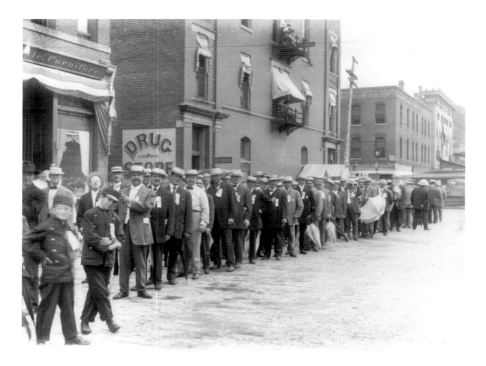

Stillwater has a rich history of fraternal organizations, which includes the Elks Club. *The Minneapolis Collection.*

is needed." In 2015, the Rotary Club had 1.2 million members and thirty-four thousand clubs in two hundred countries.

The *Turnverein* was a popular organization throughout the nation in the nineteenth century. Gymnastics, exercise and health were promoted, in addition to German culture. In 1878, the *Stillwater Lumberman* reported that the "society will give a turning exhibition" at the Opera House on February 14.

German working men also needed life insurance. The Knights of Pythias (Stillwater Lodge, No. 70)—the oldest mutual benefit organization in the state—aided Anglo American workers in 1872. The Sons of Hermann organized on January 24, 1876. Warner and Foote said, "German citizens of Stillwater, for mutual benefit, in connection with a life insurance department, whereby each member's family, at his death receives $1,000." Hermann Arminius saved the Germans from the military advances of the Roman Empire in AD 9. With twenty charter members, the organization commenced before relocating to the Hefti block in 1889.

Germans loved singing. The Gesangverein (January 31, 1859–January 27, 1863) preceded the Stillwater Männerchor (men's choir). In the *Stillwater Daily Sun*, the column "Local Items" covered the activities of the group with pride. Founded in 1875, the society met weekly with an instructor. Members paid a two-dollar initiation fee and a twenty-five-cent monthly fee. Joseph Wolf was the vice-president.

Temperance societies were rampant in the nineteenth century. In Stillwater, Folsom listed the International Organization of Good Templars Lodge (1859), Temple of Honor (1876) and Father Matthew Temperance Society (1872). Women crusaded against the evil of drink—a permissible social sphere in the restrictive Victorian era.

In the twentieth century, Stillwater women increasingly organized clubs. The All-Go Club held events in homes throughout the city. Women also formed the Primrose Club and Stillwater Reading Club.

STILLWATER OPERA HOUSE

The Stillwater Opera House was a civic triumph for approximately twenty years. The Armory Hall (1855) and the Opera Hall (1866), constructed for Joseph Carli and Samuel Mathews, were inferior predecessors. Owners L.E. Torinus, E.W. Durant, R.J. Wheeler and A.T. Jenks financed the construction on Main Street between Chestnut and Nelson Streets (1880–81).

The Opera House opened to euphoric reviews. The *St. Paul Dispatch* of May 12, 1881, said: "The new Opera House at Stillwater was formally opened to the public last night. Despite the inclemency of the weather, the house was filled to overflowing, representative citizens from St. Paul and neighboring places joining Stillwater in celebrating the happy event." Moreover, "The eye is first greeted by the cloak and retiring rooms, elegantly finished and polished." The evening's entertainment included the "Salisbury's Troubadours." Rainy weather did not disturb the grand opening. The *Minneapolis Tribune* of May 12 went further, with the headline, "Stillwater's Pride." The Opera House, despite third-city status for "some time," was deemed "the handsomest and most imposing structure west of Chicago."

The Queen Anne–style structure was designed by Abraham M. Radcliff of St. Paul for $1,000. With elements of Victorian and Gothic architecture, the 90- by 120-foot building was constructed with 600,000 bricks and Kasota stone trim. It seated 1,217 with 16 boxes and had a

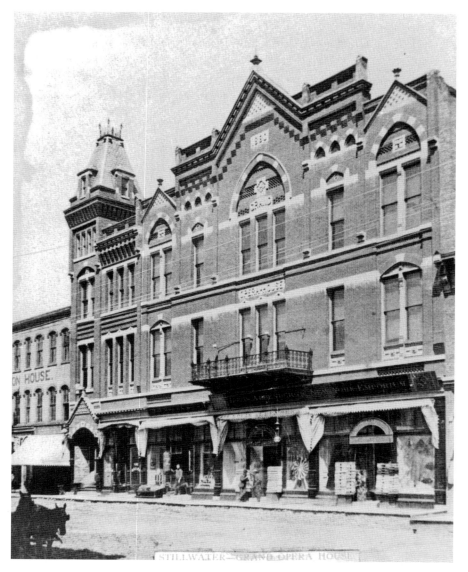

The lavish Stillwater Opera House placed the city on the regional cultural map. *The St. Croix Collection.*

steam-ventilated boiler heater. The impressive details went further: "In the center of the proscenium arch is a large medallion of Shakspeare [*sic*], and around the hall eleven others, Hayden, Schiller, Bach, Goethe, Dickens, Handel, Walter Scott, Longfellow, Mozart, Tennyson, and Beethoven,"

said Warner and Foote in 1881. They continued, "The stage, which is the finest west of Chicago, is thirty-nine feet wide by sixty-six feet long, and is supplied with all the mechanical appliances of a well-appointed stage." *Gazette* ad space was purchased in the 1890s for *Little Lord Fauntleroy, Said Pasha, Jim, the Penman, Keep It Dark* (a comedy) and Lizzie Richmond, an actress and singer.

The Opera House, however, met an abrupt finale—fire. The *Minneapolis Journal* reported on December 5, 1902, "Grand Opera House Block Burned and Two Other Brick Structures Badly Damaged." It said, "Stillwater's magnificent opera-house was totally destroyed by fire shortly after 3 o'clock this morning." The Holcombe and Disch blocks were "gutted." The newspaper continued, "The fire...was one of the fiercest and most disastrous in the history of Stillwater. The total loss is between $150,000 and $200,000 with insurance much below these figures." The article continued: "The fire was discovered in the rear of the opera-house just below the stage at 3:10 o'clock. No one knows how it originated." The paper further commented, "Only two walls of the opera-house are standing, and the ruin is complete. The building was...owned by a syndicate composed of E.W. Durant and the Jenks and L.E. Torinus estates. It was a massive three-story brick building extending from Main street and having a frontage of 160 feet....There is a small chance of being rebuilt." A grocery and shoe store were also lost. The *Gazette* said on December 5, 1902, "Great darting and burning faggots were carried for blocks away to fall upon dozens of snow covered buildings to be extinguished by the beautiful and kindly snow.... The tower and the front wall went down with a great crash."

Stillwater received fire assistance from St. Paul. When the fire was extinguished, an era ended.

POLICE DEPARTMENT

Joseph R. Brown was appointed justice of the peace—the only law officer in the region in 1838. In the 1840s and 1850s, sheriff was a part-time job—and Stillwater's chief law enforcement officer from 1841 to 1854. In 1841, Phineas Lawrence was the first sheriff in the St. Croix Valley—then, Crawford County, Wisconsin—which included the western side of the St. Croix River. After Lawrence's death in 1847, William H.C. Folsom was elected sheriff. Folsom, a humble farmhand and logger in Maine, would later become a historian, state representative, six-term

state senator and a businessman as a lumber, flour mill and a dry-goods store owner in the St. Croix Valley.

The first murder case involved two American Indians accused of killing Henry Rust, a Kanabec River trader. The weeklong trial was held at McKusick's store (Southwest Main and Myrtle Streets). Nodin and Ne-she-se-ge-ma were acquitted; it was ruled a "drunken brawl."

City marshals preceded the police. The marshal acted not only as chief of police, but liaised with the city council. Patrolmen enforced the law, while night watchmen, a part-time position with meager wages, patrolled the streets, preventing fires and other property losses. They also sounded fire alarms and maintained order and kept the peace at festivals such as Independence Day. A similar proto-police force existed in St. Anthony. Mayor John McKusick appointed his brother Jonathan McKusick as the first marshal in 1854. Later, marshals served multiple terms, like Duncan Chisholm (1860, 1861, 1862, 1863 and 1871). Matt Shortall was chief from 1873 until the 1880s. The police station (Myrtle and Third Streets) was constructed in 1879. It stood two stories tall and was twenty-eight by forty-five feet. Construction of the building cost $6,150.

Cities passed absurd police ordinances. Sherman's Bayport book mentioned ordinance No. 3 (1882), which stated: "The constable shall receive for his services the sum of 50 cents for every hog taken by him and the sum of 25 cents for every day such hog shall be kept." Finally, in 1907, police replaced constables in South Stillwater.

FIRE DEPARTMENT

The Stillwater Fire Department developed incrementally. Gradually, city officials were convinced of the necessity for emergency services. As Folsom said, "Futile efforts had been made as early as 1859 for the organization of a fire department," when "bucket brigades" passed water to extinguish fires.

Chairman W.H. Burt organized the predecessor to the fire department at Pugsley's Hall on February 12, 1859. Yet, until after the Great Chicago Fire (1871), primitive methods continued before the fire department was created. The city council in 1872 "ordered the erection of a temporary building for housing a fire engine," said Warner and Foote. Mayor William McKusick (1871–72) and councilmen drafted an ordinance for a fire department on May 31, 1872. The *Stillwater Messenger* wrote on May 24, 1872, that John McKusick and David Bronson "appointed a committee to

draft an ordinance regulating the fire department" and submitted to the city council a public meeting at the armory to organize the fire department. "A good hose company is necessary for effectual service with the steamer, while a hook and ladder company is also important." The St. Croix Hook and Ladder Company received a temporary loan for an engine house and tested a "steam fire engine" and 1,500 feet of hose.

To protect the city, the best firefighting technology was necessary—the Silsby engine. The *Messenger* reported on May 24, 1872, "At a meeting of the City Council last evening, a communication was received from the Silsby Steam Fire Engine manufacturing Company, of Seneca Falls, New York… the fire Steamer purchased by this city was shipped on the 15th." The engine was purchased for $7,325.

David Bronson, the first chief, held the title of "chief engineer." Other positions included first and second engineers, as well as three fire wardens. In addition, "The fire engine, hose, hook and ladder men divided into companies" said the *Stillwater Messenger*.

The paper also covered the "Trial of the New Fire Engine" on May 31, 1872. Named the Stillwater, "It took seven minutes to get up steam." "Many of the spectators paid the penalty of their curiosity, the nozzle men having a playful way of managing the hose. They PLAYED upon the unsuspecting natures of the small boys of the city, after a fashion that was exceedingly diverting to both parties." Mayor McKusick and the Chicago Silsby agent wagered on the engine's power. McKusick ascended to the courthouse cupola, and if a jet of water hit him, he'd treat the crowd; otherwise, the agent would. "Mayor McKusick, who stood in the open window of the cupola, was compelled to beat a speedy retreat in a moist condition." Moreover, during the test, the firefighters forced water through 200 feet of hose "full steam," and through 1,500 feet at 190 feet in elevation. On June 4, 1872, the *Gazette* reported on the first fire with the new equipment: "There was an alarm of fire on Monday evening, about 7 o'clock. It was totally unexpected to the boys, of course. But the engine and hose carts went thundering o'er the stony streets, and swiftly." The article claimed the fire response was between nine and fourteen minutes; "the boys deserve much credit for their promptness and celerity." Ironically, the fire hall was set ablaze within the first year, but the Silsby engine was spared.

A fire occurred on June 10, 1874, on a Staples property. The *Gazette* wrote of a "Lively Conflagration." The article said, "On Saturday last about 11 o'clock, the alarm of fire was sounded from the engine bell, and a dense

smoke issuing from a barn on Main street, near the St. Croix Gang Saw mills." The newspaper continued,

> *The engine was speedily drawn into the street, and the fires lighted, but the horses, ordinarily used as the motive power, being at work at a distance, some delay necessarily occurred in getting the engine in position. In the meantime the hose from the saw mill of Mr. Staples, near by, was playing on the fire in a very lively and effective manner. The flames however, burst out through the roof in a sudden and astonishing manner, owing to the fires having originated among the hay.*

Again, the paper said, the "building was saved, but in a charred, blackened and seriously damaged condition," because of the efforts of firemen and millworkers. The Miller and Hathaway shops were $2,000 losses, and a barn was a $1,000 loss. Both lacked insurance. The fire's origin was unknown. Again, the *Gazette* wrote, "We wish to bear testimony to the excellent conduct and remarkable and noticeable promptness on the part of the firemen. No danger or risk was too great." Chief Bronson said, "It was the undivided opinion of our good citizens that the boys did their duty nobly and well at all fires."

The fire department modernized as Stillwater flourished. In 1888, there were twenty-four men, including volunteers. Under Chief Frank E. Joy, there were ninety to one hundred fire hydrants and fifteen alarm boxes. A modernized fire department was an ongoing battle as technology advanced. Engineer Sanford Herberg of the General Inspection Bureau of Minnesota detailed the deficiencies of the Stillwater Fire Department in a January 1, 1932 article. The public report requested a minimum of five additional firemen, fifteen to twenty volunteer firemen, and an increase in water volume through hydrants.

Dangerous conflagrations continued to threaten the city. The Gilbert plant fire occurred when Andersen Windows had leased property for storage on May 16, 1955. The fire began at 3:30 p.m. on Monday and temporarily closed State Highway 95. Fortunately, sparks did not spread to residences, but the *Gazette* said, "Gilbert Plant Fire Loss Here Estimated at Over $300,000." Total damages amounted to $375,000 in the "worst fire in nearly 40 years." The Andersen Windows Corporation had the biggest loss, with "38 carloads of Andersen window frames" that totaled $200,000; but the damages were covered completely by insurance.

RAILROADS

Stillwater railroads developed slowly. The state legislature incorporated the Minnesota & Northwestern Railroad Company within one fourth of a mile of Lake St. Croix in March 1854. In 1856, the legislation was extended four years. The railroad was to construct fifty miles, but it did not. Congress passed a new land grant bill, and after a special session of the state legislature, four railroad companies and six lines were chartered. It was celebrated in Stillwater with brass bands, speeches and feasts on March 16, 1857. However, the Panic of 1857 and the Civil War suspended hopes for the arrival of the iron horse.

Four railroads once traversed the Stillwater area. The first was the St. Paul & Duluth, later called the Lake Superior & Minneapolis (also known as the Mississippi & Lake Superior) and then the Northern Pacific. Second was the St. Paul, Stillwater & Taylors Falls (later the Omaha Road). The Milwaukee Road in Lakeland, which linked Stillwater to Chicago, was the third. Finally, the Soo Line was completed in the 1880s.

Before the first train arrived, newspapers speculated about that transformative day. The *Gazette* of December 1, 1870, featured an article on the "road" from White Bear Lake to Stillwater. The "Rail Road Celebration," held on January 3, 1871, was attended by three hundred people. "The greatest event, so long looked for, has…dawned upon Stillwater. We are united with the entire outer world by iron bands." A band played. Speeches were expounded. Dinner was served at the Sawyer House. The paper concluded, "Thus closed the celebration of the most important era in the history of Stillwater."

Historian Matthew Josephson said in *The Robber Barons*, "The railroads, as we see, possessed the strategic power, almost of life and death, to encourage one industrial group or cause another to languish." Boorstin said, "Steamboats followed routes laid out by nature, but railroads (although never free to ignore natural contours, and inevitably guided by them) *were* the routes themselves. The railroads in the American West had the power to make a path of settlement." By 1871–72, the railroads "vastly expanded the available markets for Stillwater lumber and manufactured goods" said the "Historical Reconstruction of the Riverfront: Stillwater, MN, Army Corps of Engineers." Except during the Panics of 1873 and 1893, the rapid growth of railroads continued through consolidation, bankruptcies and convoluted reorganizations.

The railroads expanded lumber markets rapidly. "The business by rail from Stillwater was then still in its infancy; by 1875, however, it was maturing

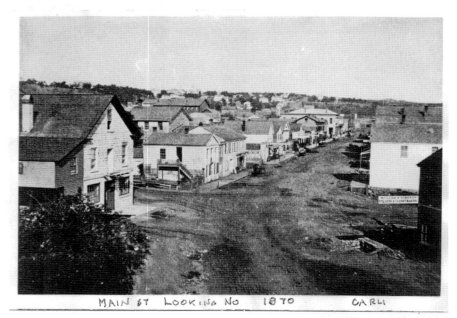

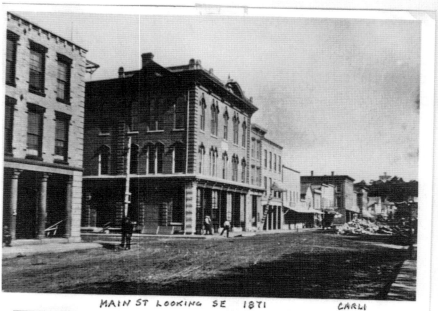

Main Street as it appeared during the halcyon days of the Stillwater lumber industry. *The St. Croix Collection.*

rapidly. In the week of June 25 of that year 141 car loads of lumber were shipped from Stillwater to points in Minnesota, Iowa, Missouri, Nebraska and Dakota," said Agnes Larson in *The White Pine Industry*. Moreover, Larson stated, the railroads caused economic expansion. "Minneapolis, Stillwater and Winona, as we have seen, increased their lumber production and expanded their market as railroads developed and opened up new regions to the westward."

The Stillwater & St. Paul Railroad Company traveled from White Bear Lake to Stillwater. John McKusick spearheaded the railroad, which stalled in legislature. The railroad was organized on January 24, 1867, and incorporated with a 63,853-acre land grant on July 24, 1867. It included a branch line from White Bear Lake. Northern Pacific (NP) purchased the railroad in an agreement with Lake Superior & Mississippi Railroad Company (LS&M), which controlled the Stillwater & St. Paul Railroad in 1867. However, Jay Cooke of NP went bankrupt in 1872–73, and in 1874, the railroad went into receivership. Despite ownership changes, the *Gazette* regularly printed ads for "direct routes to St. Paul, St. Anthony, Minneapolis" about the LS&M of the NP. The St. Paul & Duluth reorganized as the LS&M on June 27, 1877. The NP, once again, was in receivership in 1893. The NP purchased Stillwater Union Depot & Transfer Company, tracks, depot, the Lumberman's Exchange Building, engine house and warehouse for $95,000 on May 12, 1902.

The St. Paul, Stillwater & Taylors Falls was incorporated on December 4, 1869. The Stillwater to St. Paul and St. Anthony was federally mandated and incorporated by St. Paul businessmen F.R. Delano, R.B. Blakely and Peter Berkey. The Stillwater & Taylors Falls reached the city in 1870. The road to Taylors Falls was completed years later, but rails were never laid. It became the St. Paul & Stillwater Railroad. The Chicago, St. Paul, Minneapolis & Omaha Railway Company took over the St. Paul, Stillwater & Taylors Falls on May 25, 1880. Later, the Chicago, St. Paul & Minneapolis Railroad merged with North Wisconsin Railway. Then, in May 1881, the St. Paul & Sioux City Railroad was sold to the Chicago, St. Paul & Minneapolis, which set up the "Omaha Line," which was controlled by Chicago & North Western.

The Hastings & Stillwater Railroad—later known as the Milwaukee Road—was the third railroad, linking Stillwater with Chicago. The Stillwater & Hastings Railway was incorporated by E.W. Durant, R.F. Hersey, David Bronson, Charles N. Nelson, Isaac Staples, Sabin, E.L. Hospes and others in 1880. In that year, the work commenced on a road

The Union Depot once was one of two owned by separate railroad companies in downtown Stillwater. *The St. Croix Collection.*

to Lakeland that would serve Stillwater, but it stopped after two miles. The route led to Chicago, Milwaukee and St. Paul. The Milwaukee Road Freight House was completed in 1882 and competed with the Union Depot until it closed in 1950.

Stillwater's fourth railroad was the Soo Line/Wisconsin Central. In the 1880s, Minneapolis industrialists formed the line to bypass Chicago and James J. Hill's St. Paul–based Manitoba line. By following a northern route through Wisconsin and Sault Ste. Marie, reduced shipping rates realized larger profit margins; hence, the name Minneapolis, Sault Ste. Marie & Atlantic Railway, or Soo Line. The rail line represented Minneapolis millers John S. Pillsbury and William D. Washburn—and Thomas Lowry's triumph.

By 1900, Stillwater had three railroads—all branch lines. The lumber industry in Stillwater declined as the automobile age approached.

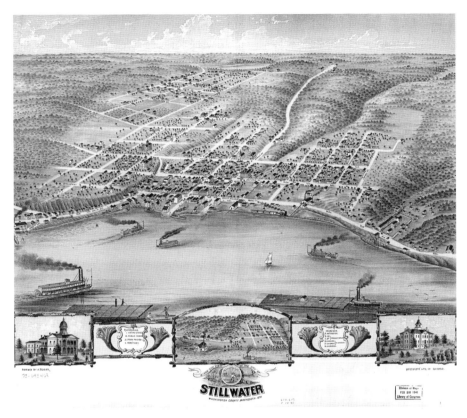

An 1870 panoramic map displayed the growth of Stillwater—and the busy St. Croix River. *The St. Croix Collection.*

STILLWATER STREETCARS AND WILDWOOD

The streetcar system linked Stillwater to the Twin Cities. As people enjoyed greater mobility and leisure time, Wildwood—an asset of Twin Cities Rapid Transit—became the preferred getaway spot. Omnipresent automobile culture and political shenanigans eliminated both civic assets.

Seven local businessmen invested $50,000 in the Stillwater Street Railway Transfer Company. Dwight M. Sabin, Louis Hospes, Isaac Staples, R.F. Hersey, E.S. Brown, David Bronson and Louis Torinus incorporated for fifty years on March 23, 1878. John W. Diers and Aaron Isaacs said in *Twin Cities by Trolley,* "Stillwater achieved distinction as having the first electric railway in the state of Minnesota." Moreover, Rosenfelt wrote, the Stillwater Street

Railway was the first "electric street railway company in the northwest." Finally, the *Gazette* of January 28, 1889, announced the electric streetcar's arrival: "While others have laughed at the idea, as chimerical and as one not likely to be consummated, we have steadily contended that the enterprise was one required by our people." When Minneapolis and St. Paul offered horse-driven systems, two lines composed the Stillwater Street Railway. The initial electric streetcar traveled on June 25, 1889. Tracks were laid on Stimpson Alley (present-day Water Street). The concisely named Transfer Company was rechristened the Union Depot Street Railway & Transfer Company of Stillwater.

The Stillwater streetcar system was consolidated within a decade. The Minneapolis & St. Paul Suburban Railroad—or Twin Cities Rapid Transit Company (TCRT)—eyed the St. Paul & White Bear Lake Railroad. Thomas Lowry sought the Stillwater line for the TCRT. The board of directors included Minneapolis scions John S. Pillsbury and William D. Washburn. Stillwater mayor Pattee deliberated on March 9, 1899, until the time limit expired before he vetoed. C.G. Goodrich of TCRT agreed to "formidable concessions," and the Stillwater City Council granted the electric streetcar franchise from St. Paul to Stillwater on March 22, 1899. This time, Mayor Pattee signed. The link with the 523-mile transportation street railway was "a system that stretched from Lake Minnetonka to the St. Croix River and carried more than 200 million passengers a year," said Diers and Isaacs. The state prison (in South Stillwater) was a TCRT destination. Prisoners were enchained in special cars with brass seat handles.

Wildwood was a popular leisure destination. In 1883, the fun park was platted in Grant Township on the southeast shore of White Bear Lake. Kathryn Strand Kotsky and Linda Kotsky wrote in *Minnesota Vacation Days: An Illustrated History*, "When people living in Minneapolis and St. Paul were looking for one-day vacations, amusement parks or 'picnic resorts' provided the answer." Wildwood also hosted business, club and family gatherings. The facility was upgraded with a refreshment center, pavilions, rowboats, swimming, bowling alley, roller coaster, carousel, penny arcade and more.

Unlike Big Island (on Lake Minnetonka), Wildwood existed for over fifty years. But improved highways and affordable automobiles caused the park's decline. The *Stillwater News* chronicled weekly efforts to terminate the line. A hearing was held to close the Wildwood & Stillwater and the Wildwood & White Bear lines in January 1932. Both Wildwood lines were maintained on July 29, but discontinued later that year. Worse yet, Wildwood suffered from repeated robberies and bad publicity. The July 3, 1933 *Gazette* reported,

"Drunken Gunmen Rob Wildwood Park." Posing as sheriffs, men stole $3,500 from the manager's home.

Wildwood closed in 1938. The streetcar was a casualty of suburbanization, the automobile and the Eisenhower National System of Interstate and Defense Highways.

MINNESOTA STATE PRISON AND POOR FARM

The lack of a territorial prison concerned Governor Ramsey. Prisoners regularly escaped from Fort Snelling. John McKusick, E.A.C. Hatch and Louis Robert headed a commission to locate the state prison. Ramsey suggested a $20,000 appropriation that was approved by the territorial legislature on June 1850. Folsom said it was "generally conceded that the site for the prison was badly chosen. The ground, nine acres, was mostly quagmire, and was, moreover, crowded in a ravine between high bluffs."

The Jesse Taylor Company received the prison construction contract. At Battle Hollow, Francis R. Delano, Martin Mower and John Fisher constructed the stone prison—a three-story, thirty- by forty-foot structure with two dungeons, in 1851. Six additional cells, two dungeons and solitary confinement were completed in 1853. The next year, the first warden, Frank Delano, inaugurated a succession of profitable conflicts of interests.

On the prison grounds, Delano, "With his own funds…purchased and took into the government-constructed penitentiary about eight thousand dollars worth of steam-powered machinery for the manufacturing of shingles, sashes, doors, flooring, wagons, and plows," said Dunn on May 31, 1872, in "The Minnesota State Prison During the Stillwater Era, 1853–1914" in *Minnesota History* (1960). In addition to hard labor, the prisoners lived in overcrowded cells. "Most of the time, two and often three men were forced to share a single unit," said Dunn. Prison problems were widespread. The *Stillwater Messenger*, on November 24, 1857, printed a "Report of the Grand Jury of Washington County upon the Territorial Prison." It stated, "In the discharge of our duties we have visited and examined the Territorial Penitentiary, situated in the city of Stillwater." Delano allowed eleven prisoners to escape after April 1855. Worse yet, five prisoners were discharged after counties did not pay incarceration fees. Moreover, the prison was administered in a "negligent and careless manner." Finally, "It also appears that the keys to the prison and cells were kept in so careless a manner in the office, that they were accessible

County poorhouses offered relief to the impoverished in return for labor. *The St. Croix Collection.*

not only to persons in and about the prison, but to outsiders." The end result: an eight-count grand jury indictment. After Delano's term expired in 1858, the charges were dropped.

The Stillwater prison switched gears after this embarrassment—if only slightly. Businessman John B. Stevens initiated the prison labor "contract system," which continued until the prison closed fifty-five years later. Stevens manufactured shingles and blinds with prison labor, but his shingle factory burned in 1861. He went bankrupt.

In his place, George M. Seymour (1829–1892) used contract prison labor. The New York–born carpenter was a contractor and later operated a cooperage. After arriving in 1859, he repeatedly expanded the prison, adding the prison grounds in 1861 and, later, the hospital, deputy warden's house, chapel, guard's room, mess, kitchen, prison offices and additional cells. Seymour and William Webster also produced flour barrels. When the implement factory was in an embryonic stage, 225 prisoners worked at the Western Shoe Company.

Seymour, Sabin & Co. formed after Dwight M. Sabin arrived in 1867. Originally from Illinois, he served in the Minnesota State Senate (1871–73)

and U.S. Senate (1883–89). The firm produced doors, blinds and sashes, and it had a cooperage that employed prisoners and locals.

By 1876, the Minnesota Chief was the largest thresher maker in the world. Sales totaled $135,000 in 1871. A labor force comprising seven hundred prisoners performed much of the work at the firm. *The State of Minnesota; Its Agriculture, Lumbering and Mining Resources* stated in 1885, "The celebrated Minnesota Chief Thresher and Separator is manufactured here and also very superior railway cars." But, once again, controversy marred the success of prison labor.

Before Sabin went to Washington, criticism of prison labor continued. Distrust of "profiteers" soon mushroomed. "Over the succeeding three years antagonism toward the contract system increased, as it became the general opinion that the institution was being managed at too great an expense to the state and too large a profit for the contractors," said Dunn. Others were less critical. The *Stillwater Messenger* said on August 9, 1872, "Convicts who have enjoyed similar hospitalities in other states, invariably speak of the Minnesota prison in the highest terms." In the same issue, under the subhead "Value of Manufacture," the paper strongly advocated prison labor, saying, "Some idea of the importance in a manufacturing sense of the work in the prison shops and building, is shown from the fact that the sales of Seymour, Sabin & Co. the past year, amounted to $135,000."

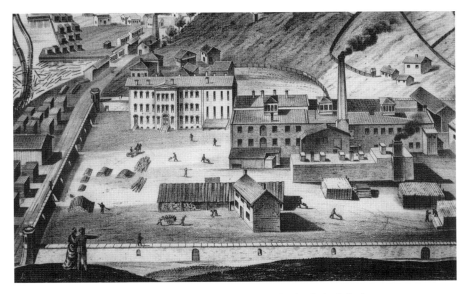

Stillwater Prison, when prison labor was big business. *The St. Croix Collection.*

The state legislature vacillated. In 1881, Seymour, Sabin & Company earned $300,000 in net profits. Finally, the state legislature bowed to pressure from the St. Paul Trade and Labor Assembly in 1887. Prison labor was barred from competing with "free enterprise." The Seymour, Sabin & Company deal ended, leaving four hundred prisoners unemployed. But the lucrative business of prison labor quickly returned. In 1889, prisoners labored again because of the "disastrous effect of idleness on prisoner morale," said Dunn's article.

The "Minnesota State Prison Fire" occurred on January 12, 1884. The sash, door and blind shop burned on Thursday, January 7, after $140,000 in losses for Northwestern Manufacturing & Car Company. The *Stillwater Messenger* wrote that the fire "almost instantly swept through the whole building, embracing pattern, hardwood, and wagon shops and boiler room." Then, a second fire occurred on January 25, 1884. Beneath the office of the car company, the fire "swept through" main prison cell buildings, causing $30,000 in estimated damages and leaving one prisoner dead.

Northwest Thresher Company was the leader in commercial farm manufacturing equipment. *The St. Croix Collection.*

Then, there were legal problems for prison labor. The *Gazette* of April 25, 1888, stated, "The Minnesota Thresher Manufacturing Co. will commence suits against the stockholders of Seymour, Sabin & Co., and the Northwestern Manufacturing and Car Co., for dividends paid but not earned." Eastern capitalists pursued the train car company's purchase. Due to "economic schemes," the company accumulated $2 million in debt. Creditors reorganized as Minnesota Thresher Manufacturing Company (November 25, 1884). The *Stillwater Democrat* wrote on January 12, 1888,

> *Senator Sabin left for Washington on Thursday evening last accompanied by the eastern capitalists who had been here to conclude the final purchase of the Car company's property. Before leaving they saw the Minnesota Manufacturing company in full possession of their property with W.S. Goodhue assistant manager in charge.*

Business ended for Sabin—but not politics.

After serving a second term in the state senate, Sabin defeated Senator William Windom in 1883. He was elected to the U.S. Senate before the Seventeenth Amendment (1913) of the Constitution was ratified. Senators were elected by state legislatures, not popular vote. Sabin won on the sixth ballot, but only served one term. He was defeated by William D. Washburn. The *Gazette* reported on January 18, 1889:

> *The new Senator, Hon. W.D. Washburn is a man that our state need not feel ashamed of. He is well qualified for the important position to which he has been chosen, and our county would have been well satisfied to endorse his candidacy if it had not been for the fact that our own townsmen was entitled to its support and was worthy of a re-election.*

Sabin accepted defeat ungraciously. In the *Gazette* of January 21, 1889, state senator William G. Ward claimed "corrupt methods were practiced in order to secure Washburn's selection." He asserted that "boodle" was used to win the election. The two statehouses voted separately on January 22. One day later, Sabin was defeated by Washburn. Political power shifted in the state, too, from Stillwater to Minneapolis, and from lumber milling and prison labor to flour milling. After a house objection, the members voted *viva voce*, with the same results: Washburn was victorious. Finally, Sabin submitted, saying in the January 24 *Gazette*, "The campaign we have run, against the combined interests of Minneapolis influences and capital,

The Social Security Act reorganized relief in 1935. Public welfare assistance was "consolidated" and became Washington County welfare on July 1, 1937. Finally, director James Zellner informed the *Gazette* of the farm's closure on May 11, 1973. The dairy herd, crops, feeder cattle and 280 pigs were sold. Today, it is Pine Point Regional Park.

THE YOUNGER BROTHERS

Thomas Coleman "Cole" Younger was Stillwater's most infamous criminal. Born in 1844 in Lee's Summit, Missouri, he served time for crimes committed in the Northfield Raid.

The Younger and James brothers raided Northfield on September 7, 1876. After the robbery of the First National Bank with Clell Miller, Bill Chadwick, Charly Pitts, Woods and Howard (the last two were pseudonyms for Jesse and Frank James), Cole and his brothers Bob and Jim received life sentences in 1876. Cole was imprisoned on January 26, 1884.

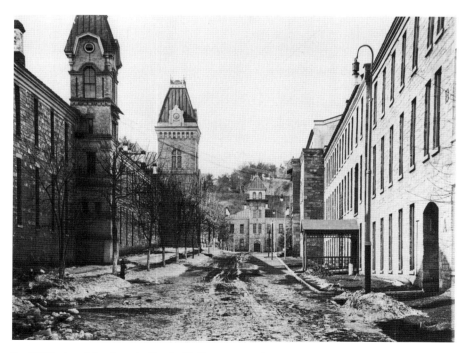

By 1902, the old prison in Battle Hollow was antiquated and overcrowded. *The St. Croix Collection.*

In his autobiography, Cole wrote, "When the iron doors shut behind us at Stillwater prison I submitted to the prison discipline with the same unquestioning obedience that I had exacted during my military service, and Jim and Bob, I think, did the same." The brothers involved themselves in the newspaper—the *Mirror*. Robert Younger died in prison on September 16, 1889. Years later, the two remaining brothers petitioned for parole. The *Gazette* wrote about the petitions on July 10, 1901. "I expect I will be like a ten-year old boy in town for the first time when I get out," Cole reportedly said in Warden Harry Wolfer's office. W.A. Blair visited Stillwater Prison "in order to get a peek at Cole Younger." Between 1889 and 1899, Cole Younger petitioned for a pardon. Jim and Cole, after twenty-five years of incarceration, waited months for release. The *Gazette* reported on July 11, 1901, "Youngers Are Not Out." First, they needed jobs. P.N. Peterson Granite Company (St. Paul and Stillwater) offered employment. They were paroled on July 14, 1901, and pardoned a year and a half later—on the condition they leave Minnesota.

Cole died on March 21, 1916.

THE MODERN MINNESOTA STATE PRISON

In 1891, Warden Albert Garvin was the first penologist. William Heilbron said about "modern penology":

> *A prisoner is enabled by meritorious conduct to reduce his original sentence to a marked degree the parole and grading system, which permits the release of a first offender at the expiration of half his sentence; the establishing of prison night schools, enabling him to learn a trade during imprisonment and permitting him to have books, papers, magazines, etc.*

Charles Flandrau was also overly impressed with reforms in 1900:

> *All prisons where criminals are sent to work out sentences for crimes committed are alike on general principles, and the Minnesota prison, situated at Stillwater differs only in the fact that it combines in its administration all the modern discoveries of sociological research which tend to ameliorate the condition of the prisoner and fit him for the duties of good citizenship when discharged.*

Three lumber mills shut down. Schulenburg & Boeckeler was "added to the list this week." Also the Anderson, the Hersey and the St. Croix Lumber Company closed in 1887, said the *Mississippi Valley Lumberman.*

The *Mississippi Valley Lumberman* reported Professor Charles S. Sargent's lecture, "Our Future Timber Supply": "Prof. Charles S. Sargent, one of the special agents of the tenth census, in his report on the forests of North America," said the future of lumbering was in Michigan and Pacific forests. He concluded, "The area of the pine forest, however, remaining in the great pine producing states of Michigan, Wisconsin and Minnesota is dangerously small in proportion to the country's consumption of white pine lumber, and the entire exhaustion of these forests in a comparatively short time is certain."

Natural disasters also undermined the logging business. In the "local news," publisher H. Folsom of the *Taylors Falls Journal* was blindsided by the events of June 27, 1882. The paper reported: "Plenty of rain lately," "river at good driving stage" and "logs are floating in the river." On the same day, "the greatest logjam yet known on the St. Croix" formed between Marine and Arcola. The next year, "Continuous log jams were the bane of the lumbering business. For fifty-seven days in a row this year, no logs broke through the river's narrow bend at the Dalles, preventing Walker, Judd and Venzie from getting enough logs to the mills to fulfill its contracts," said Dunn from *Marine.* Another disaster occurred when a tornado hit the St. Croix Valley on September 9, 1884: "About a half a million feet of high-grade…lumber was blown away." John G. Rose sold the Marine Mills Creamery Company to a Hennepin County company. In 1887, the buildings were converted to homes.

Dominated by Stillwater lumbering, the surrounding commerce dwindled. Marine Mills' greatest population, 679 residents, occurred in 1890. In 1895, Dunn said in *Marine,* "Marine Mills was the last of the eight sawmills above Stillwater to go." James Burris and son sold the machinery to Stillwater and Minneapolis firms—a sign of the times.

Stillwater's largest population was 16,500 residents in 1887–88. Then, there were forty-two saloons and seventeen churches—a common working-class dichotomy. Until early in the twenty-first century, Stillwater's population did not entirely recover.

In 1884, when Edward Brown's partnership ended, Hersey and Bean hired bookkeeper George H. Atwood. By 1891, he leased the mill. As the director of the Mississippi Valley Lumbermen's Association that year, he was the first to transport lumber by rail.

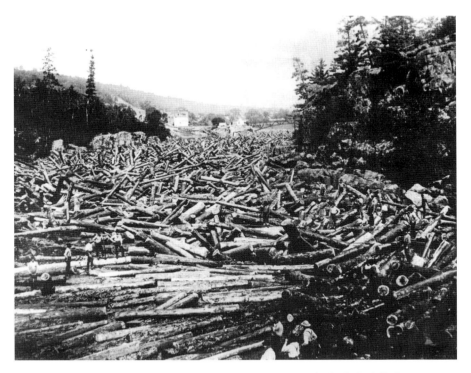

The 1886 logjam occurred at the lumbering industry's apex. *The St. Croix Collection.*

On July 14, 1893, a tornado hit the lower Main Street sawmill. In "The Story of the Cyclone," Will E. Cowles wrote that two men were killed: Windom A. Anez, forty-six, married with several children; and Samuel Simonson, thirty, an unmarried Norwegian immigrant. In addition, thirteen more persons were injured. From Lily Lake, the cyclone traveled to Lake St. Croix and South Fourth Street. There was "considerable damage." A fire at the Atwood Mill was quickly extinguished. The namesake insured the fire department's dispatch; damages totaled $20,000. Also, the Steinacker brickyard suffered a $2,000 loss. Louis Stolz was "bruised and stunned." He reported:

> *I heard a terrible roaring in the woods beyond Lily Lake. Suddenly it began to grow dark, and I heard one of the women call from the house. Then there was a rush and roar and the entire roof and shed were carried into the air; pieces of timbers and flying brick were hurled all around me, some of them striking me in their descent. My horse became unmanageable and*

backed out of the ruins, knocking me down as he went. I must have been unconscious for a few minutes, and recovering found myself pinned under some heavy timbers.

Stolz received chin and head abrasions. A one-hundred-pound door hurled from the mill could not be found, he reported.

According to McMahon and Karamanski: "As the scale of logging increased, so too did the emphasis upon efficiency. As efficiency became a virtue of management, logging was increasingly mechanized." Even Isaac Staples's business was affected. "Yet, for all his success, by 1885 Staples, perched in his Victorian mansion high on a bluff with the valley spread out before his feet, represented the past, not the future, of the St. Croix lumber industry," said McMahon and Karamanski. Frederick Weyerhaeuser purchased regional logging with his Mississippi River Logging. He pushed to improve the St. Croix to the efficiency of the smaller Chippewa River. William Sauntry was employed as Weyerhaeuser's local lumber agent. He purchased timber lands from Staples—to Sauntry's horror, without Staples's knowledge.

The pioneer loggers could not imagine forests exhausted so fast. Captain Edward W. Durant said in a Minnesota Historical Society paper in 1906, "The magnitude of the lumber industry of the St. Croix valley is almost beyond the comprehension of anyone who has not applied himself to a thorough study of the subject from every standpoint." He continued, "Even the primitive logger of pioneer days had only a poor idea of the almost limitless timber resources of the district."

Folsom described lumbermen in 1888: "The St. Croix lumberman, after the lapse of nearly fifty years, is still a picturesque figure, clad, as he is, in course, strong woolen garments, these of brilliant red, yellow, blue and green." However, the future was uncertain. Folsom continued: "Who can tell what a day or another fifty years may bring forth? The pine woods will not last always; already the camps are being pushed further and further to the north and west, and wherever the denuded pine lands are arable the farmer is making his home." He described the trajectory of logging, "Everything is done on a larger scale and more economically." As Hart and Svatek Ziegler concluded, "This golden age was also nearly its terminal stage, because larger operations could cut down forests so fast. As a result, the lumber business declined rapidly after its peak. By 1907 lumber had become so expensive that the construction industry began to shift to cement and structural steel."

4

STILLWATER IN TRANSITION

*By 1869 there were fifteen sawmills at or near the Falls of St. Anthony.
The Minneapolis lumber business leaped far beyond that of Stillwater as
expansion continued in the 1870s and 1880s. By 1890 Minneapolis,
cutting close to a half billion feet, was the premier lumber market not only of
Minnesota but of the world.*
—*Theodore C. Blegen,* Minnesota: A History of the State

*But when the vast timber lands gave out, the silent pall which every other
lumbering city had experienced settled over Stillwater. St. Paul began to flourish as
the terminal of trade routes, and flour mills brought fame to Minneapolis, leaving
Stillwater out of the race to face its slow adjustment to a great change.*
—*Emma Glaser,* Minnesota History *(1943)*

When the logging era ended, Stillwater could not compete with the
Twin Cities for regional economic supremacy. What was next? When
the boom closed, the city struggled with local floods and national crises—
particularly, World War I, the Depression and World War II. Over decades,
Stillwater adapted, the St. Croix River rejuvenated and a scenic river town
was born.

"The St. Croix is the highest in ten years. As a result, there has been a
clean drive of logs. The boom is banked up logs six feet deep and will be
unable to begin the sorting of the logs until the water falls. The stage is now
13.3 feet and stationary," the *Washington County Journal* matter-of-factly stated

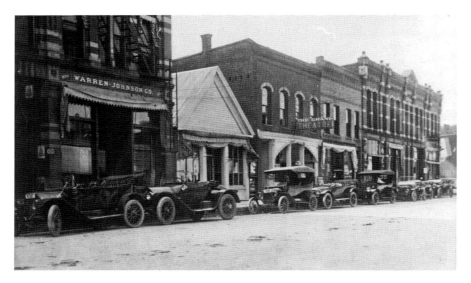

During World War I, the St. Croix Valley's white pine industry was nearly exhausted. *The St. Croix Collection.*

on May 10, 1912, concluding, "It is expected that the St. Croix boom will start next week. This will be the final season for driving on the St. Croix." It held on a few more years.

Months later, the same paper reported, "Former Citizens Welcomed Home." Stillwater held a homecoming on Thursday, Friday and Saturday—not for high school students, but for former Stillwaterites. It involved desperation and, on a brighter note, was the precursor to Lumberjack Days (the first held in November 1934). The homecoming included similar events—"Tonight there will be log rolling and a water carnival in which hundreds of decorated canoes, launches, and water craft of all kinds will participate." Mayor Carl W. Brenner wrote an editorial, "Stillwater of the Future: A Prophesy." In it, he said, "In view of the 'Home Coming Festival' which is being held in our city as you go to press… you have asked me to write about…'What do you think of the future of Stillwater?'" He suggested the city acquire dredges after the completion of the Panama Canal, and dig "a canal which will connect the Brule River with the St. Croix." He wasn't the first to suggest this. Moreover, he added, "This then marks the place on the St. Croix river where barges may be stored…and again we find Stillwater the first point on the river where proper terminals may be had for transferring cargoes from barges to the

railroads." Once again, the mayor said, in the *Washington County Journal* of September 6, 1912, "To my mind Fall River, Mass., occupies the same juxtaposition to Boston as does Stillwater to the Twin City [*sic*]."

George H. Hazzard was the first St. Croix River Association (SCRA) commissioner, in 1911. The leader of Interstate Park, Hazzard advocated "building a ship canal from Lake Superior to the head of Lake St. Croix, with the preferred route from there to the Twin Cities via the Brule and St. Croix rivers." In 1872, politician Ignatius Donnelly advocated such a route. The Army Corps of Engineers studied possible canal projects while lobbying the War Department in 1912. H.H. Harrison, an engineer from Stillwater, concurred. At the SCRA meeting at Taylors Falls, he said, "I will with your permission, go on to explain how this could be successfully done and continue the good work, on up this, the beautiful St. Croix River to Lake Superior," on July 18, 1912.

Meanwhile, the Army Corps of Engineers made a similar statement in the April 6, 1916 *Gazette*. A canal linking Lake Superior and the Mississippi with the St. Croix River was examined. In the ongoing story, the *Gazette* wrote, "St. Croix to be improved" (May 2, 1931), while the *Stillwater News* stated on April 1, 1932, "River Group to Meet at Bayport," in which the St. Croix River Improvement Association would discuss "restoration of the banks of the St. Croix" with trees. Again, under the auspices of the SCRA, "A boat equipped to remove snags is expected here within the next ten days and snags in the channel north of this city will be removed."

Dunn stated in *Saving the River*, "With the decline of lumbering, St. Croix river towns languished." The organization originated after Nevers Dam was constructed three miles north of St. Croix Falls by Milwaukee Bridge & Iron Works in 1890. George Hazzard created the St. Croix River Association, inspired by the inability to control water volume through St. Croix Falls—especially for fishermen. From today's perspective, the organization's aims were mixed and even contradictory. Hazzard was not a preservationist, but a Progressive-era pragmatist. As the lumber industry steadily declined, the SCRA began in 1911. In 1923, Stillwater postman Ira King revived Hazzard's organization. King, of Stillwater Council No. 347 of the United Commercial Travelers (UCT), attempted regulating the water volume at St. Croix Falls.

The SCRA advocated halting commercial fishing, and Judge A.P. Stolberg banned the practice on Lake St. Croix on July 22, 1931. The decision "upheld" state Game and Fish commissioner W.D. Stewart's earlier decision. In 1952, the group campaigned against sewage dumping into the river.

As the lumber industry wound down, conservation, nature and tourism won out. But the process was gradual, and subject to the whims of the regional, state and national economy.

FROM FOREST LANDS AND
INDUSTRIAL RUINS TO PARKS

Before the demise of lumbering, government officials and citizens considered the future of Stillwater and the St. Croix River. Scenic vistas were preserved and remediated; parks became the focal point and reshaped the identity of the former logging town.

On September 1, 1894, two fires converged and created the Hinckley Fire, which blazed through dense forests and one-hundred-foot tall trees, while temperatures reached 1,600 degrees Fahrenheit; 413 people died. The fires "were in an extreme state because of the irresponsible logging practices being followed," said Walt Tomascak in the foreword to *Hinckley and the Fire of 1894*. The fire convinced lumbermen of the forests' inherent danger, and they considered forestry science to manage these resources.

Following the fire, Minnesota and Wisconsin created Interstate Park in 1895; it was the first park system in two states. George Hazzard, the future superintendent of the park, in the 1893 session, lobbied state senator William S. Dedon before the fire. Wisconsin passed park bills on April 19, 1895, and Minnesota on April 25.

Lowell Park redeveloped a former freight yard. It was once littered with industrial waste, and the reclamation began after Northern Pacific Railroad leased the lands on July 16, 1908, for twenty years of waterfront improvement. Later, tracks and buildings were removed. The park was named after local businessman Elmore Lowell, the son of Albert Lowell, owner of the Sawyer House. The park was initially named the "Levee Park." The upper levee was dedicated by the Northern Pacific and included the assistance of the Special Levee Improvement Committee on April 19, 1912.

Robert C. Vogel, in *Stillwater Historic Contexts*, said the park was Stillwater's first attempt at "a system of intelligent planning." It was "inspired by the City Beautiful Movement, a natural revival of urban planning and design launched at the Chicago World's Columbian Exposition in 1893....A group of Stillwater civic and business leaders succeeded in having the city government create a commission to study local improvement projects." The movement advocated improved streets

As the lumber industry faded, businesses diversified into other fields; for example, Simonet's Funeral Home. *The St. Croix Collection.*

and public parks. W.A. Finkelberg of Winona designed the park in 1911 and added an expansion in 1917.

Pioneer Park, originally "Pioneer Picnic Park," was gifted in 1935 after Staples's mansion was demolished. The *Stillwater Messenger* stated on July 12, 1872, "The site is undoubtedly the noblest in Stillwater. It commands a view of the city, the lake both up and down, in fact of every thing that is picturesque and beautiful in this vicinity."

In Stillwater, public parks were reconstituted in the post-logging era. But numerous industrial companies continued after lumbering, for example Simonet Furniture, Stillwater Garment Company, the Smithson Paper Box Company, Minnesota Mercantile Company, grain mills, Connolly & Foote and Schultze shoe companies, Muller Boat Works, Twin Cities Forge and Foundry and more.

THE LAST LOGS, WORLD WAR I
AND THE GREAT DEPRESSION

In 1918, Anthony U. Morell and Arthur R. Nichols authored the "Plan of Stillwater" within five years of the St. Croix's last log drive. Until the 1960s, civil engineers planned cities and excluded historic preservationists. Then, in the 1970s, a few visionaries imagined Stillwater's future—not as a middling industrial city, but as a destination for tourists and family getaways.

The lumbering era's demise inspired reflection, which appeared on page two of the newspaper. The *Gazette* wrote on April 17, 1913:

> *The last drive of logs on the famous logging stream—the St. Croix river—is being made. The St. Croix Timber Co. of Stillwater has a large crew of drivers picking up the rears of many seasons driving which have been hung up on account of the decay and washing out of dams, which in former years, when logging was in its best, were maintained and kept up for the purpose of holding a head of water and supplying it to the St. Croix as log drives were in need of it.*

The paper continued, "The only standing timber now on the St. Croix is at the headwaters near what is known as Bear Lake" and deadpanned, "The logging industry is a thing of the past on St. Croix waters." The *Gazette* reported, "Logging on the St. Croix Closes" on June 11, 1914, and that "the last log will go through the St. Croix boom tomorrow afternoon. Superintendent Brennan so reports this morning." The article continued, "The river will be cleared, and the St. Croix as a logging stream will pass into history." Larson's article also traced the trajectory of logging:

> *In the period of the nineties the valley reached its golden age in the great industry of lumber. No one dreamed even then that, before another generation was to pass, the last log from the St. Croix would have made its way downstream. But it was to be so, for on August 12, 1914, the old boom master, Frank McGray, hitched the last log that went through the St. Croix Boom. It was the last of millions, even billions. The great empire of white pine on the St. Croix, of which Stillwater had been the capital city, had been removed to build a greater empire on the prairies of midland America.*

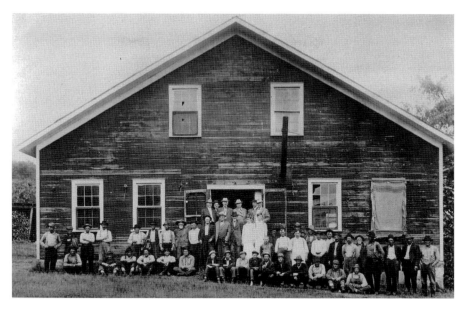

In 1914, the St. Croix Boom cookhouse celebrated the last day of lumbering in Stillwater. *The St. Croix Collection.*

After lumbering collapsed, allied industries dried up. Minnesota Thresher closed.

The population of Stillwater plummeted. In 1900, Stillwater's population was 12,318, third in the state after Minneapolis and St. Paul, but it was almost halved to 7,735 by 1920. McMahon and Karamanski wrote, "The unregulated free market of the logging era left the Lower St. Croix choked with logs and silt and partially stripped forests. The Upper St. Croix was a moonscape of land denuded of much of its flora and fauna." The authors continued, "Guilt over this environmental disaster, however, was not in the psychology of nineteenth-century lumbermen or state and local officials." But lumbering ruins were visible everywhere, from the stumps to the dump by the St. Croix. Environmentalism was a progressive reform, then. No mass movement yet existed in America. The Depression and devastating unemployment made preservation more unpalatable.

During World War I, the Stillwater press focused on local servicemen; then, the headlines turned to jobs. Front-page articles chronicled employment. For example, *Stillwater News* stated on January 22, 1932, "Connolly Shoe Co. to Reopen Monday." The factory had shut down "several weeks ago." "All" returned to work and new orders were received. Tom Gerson, vice-president

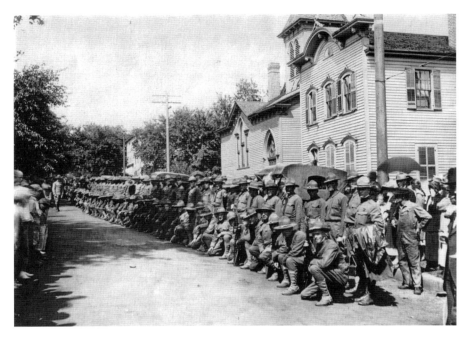

As the lumber industry declined, Stillwaterites patriotically volunteered for World War I.
The St. Croix Collection.

and treasurer (1933–67), said in "Connolly Shoe Company History" that the company opened in 1905 and "started to supplant the declining lumber payroll." The venture created for unemployed lumbermen almost closed in 1931. Stillwater and in-state financial backers considered pulling the plug. Fortunately, they did not.

In 1930, there was the "biggest drop-offs in residential building that this country has ever known." The *Gazette* reported, "Bayport Frame Plant Re-Opens Next Monday," with 250 men on the payroll on January 31, 1931. Andersen operated a "partial crew" during this economic downturn. However, "master frame" was introduced to "great success."

Hans Andersen (1854–1914) founded the Andersen Corporation in 1903. Born in Denmark, he settled in Maine at age sixteen and, later, in Hudson, Wisconsin. In 1913, he relocated and sold "stock window frames" in South Stillwater. In 1914, he signed a profit-sharing plan but soon died from a heart attack. In 1926, Fred G. Andersen received the first of many patents. By 1928, one million window frames were produced when the Depression hit.

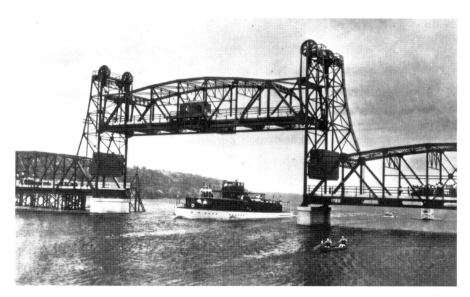

In the depths of the Depression, the Lift Bridge provided employment and linked Stillwater with Wisconsin. *The St. Croix Collection.*

In the anthology *Stillwater, My Hometown and Yours*, Harry Peterson described the 1920s and 1930s. "It was then a town of busy factories, concentrations of ethnic groups, a scattering of grade schools and grocery stores and meat markets serving neighborhood needs, a street car line connected with St. Paul, two movie theaters—all things now just a memory." It was a city unlike today: downtown factories, two shoe stores, two garment factories, a millwork company, railroad equipment manufacturer, two road grader producers and a creamery. Several businesses, like Gilbert Manufacturing, produced road graders after purchasing Twin Cities Forge and Foundry in 1927. In 1935, the company went out of business.

The 1,050-foot "Minnesota-Wisconsin Interstate Lift Bridge" was completed on July 1, 1931. An opening gala was held. "City dons Gay Attire for Big Bridge Jubilee," said the *Gazette*, "Over 15,000 attend fete in Stillwater." It continued, "Streamers of flags were stretched across downtown streets and gave the city a holiday attire. Flags will also decorate the white way posts." WCCO radio broadcasted Minnesota governor Floyd B. Olson's speech. During the heat wave, the Lift Bridge was not raised. The first boat passed through on July 2.

The Lift Bridge became Stillwater's iconic symbol. In the early 1930s, Minnesota created the state tourism bureau. The organization struggled

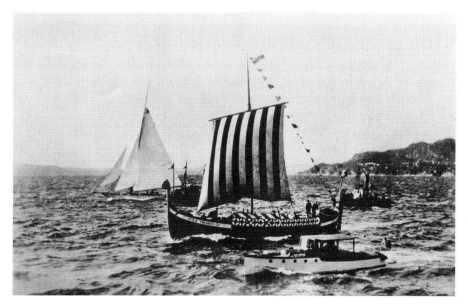

Region-wide festivities celebrated the opening of the Lift Bridge; the Viking recreation *Roald Amundsen* was showcased. *The St. Croix Collection.*

during the Great Depression and World War II, but it continues today. Hunting, fishing and tourism attracted visitors to the St. Croix Valley from the Twin Cities and beyond.

STILLWATER ART COLONY

In the post-lumber era, the Stillwater Art Colony reinvented the city as an active arts supporter. Jo Lutz Rollins, the University of Minnesota's Studio Art Department instructor (1927–65), taught and painted watercolors. She served as president of the Minnesota Art Association (1963–66) and as the "director and guiding force of the Stillwater Art Colony from 1934 to 1950," said Anita Buck in *Jo Lutz and the Stillwater Art Colony*.

Lutz Rollins was a school district art instructor and occupational therapist when Ruth Raymond of the University of Minnesota invited her for a drawing position from 1927 to 1929. In 1930, Rollins studied with Cubist painter Hans Hoffman in Munich. Later, she received a master's degree from the University of Minnesota in 1940.

Inspired by Grant Wood's art colony in Stone City, Iowa (the Stone City Colony), Rollins studied with artists and craftsmen. Composed primarily of Upper Midwest artists, the Stillwater Art Colony lacked nationally renowned artists. But Rollins had different goals. The staff included, at one time, every big artist in the Twin Cities, such as Stillwater painter Sebastian Simonet, Minneapolis Institute of Art instructor Alexander Masley and Cameron Booth.

Booth affected Lutz Rollins's art and the colony. The University of Minnesota faculty member (1957–58) also taught at Minneapolis School of Art and headed the Art School of St. Paul Gallery. His style had evolved from Cubism to Abstract Expressionism by the 1960s. Appropriately, Booth's paintings were featured in the Tamarack Gallery opening in 1973.

The Stillwater Art Colony began as the Little Art Colony. In the first year, 63 artists were taught from seven Northwest states with 1,500 visitors. The session commenced in Prescott, Wisconsin, in 1933, but a new site was needed.

The Stillwater Art Colony helped reinvent the city as a supporter of the arts. *The Minneapolis Collection.*

In 1934, the Stillwater Association welcomed the Little Art Colony, which temporarily used the McGrath house (416 South Fourth Street) while the family summered in Danbury, Wisconsin. Classes were taught in drawing, painting, portraiture and metalworks in the enormous house. The colony semi-communally shared duties. For example, for dinner, a cook was hired, but breakfast and lunch were self-service.

In 1935, the colony relocated to the Hugh Campbell house (506 West Pine Street). During World War II, not surprisingly, the colony lost focus. In the summer of 1950, the art colony closed so that Lutz Rollins could travel.

NATIONAL WILD AND SCENIC RIVER ACT

With local, state and federal oversight, Stillwater gradually preserved architectural landmarks and the St. Croix River. McMahon and Karamanski wrote in 1957 that Theodore A. Norelius, editor of the *Chisago County Press*, was the "first to voice the opinion that the St. Croix's scenic and recreational features deserved national attention." Even earlier, Morell and Nichols, in the "Plan of Stillwater," presciently suggested that "The high cliffs and beautiful wooded banks, from Stillwater to Taylor's Falls, should be incorporated into a tremendous park which will furnish country-wide attraction."

Locally, of course, "St. Croix River Association has been from the beginning a grassroots affair, linked inseparably with the St. Croix River itself," said Dunn. Legislation originated with Wisconsin senator Gaylord Nelson, who, as a Boy Scout, sailed on the St. Croix and, decades later, advocated for the river.

The first step was the Federal Wilderness Act (1964). The U.S. Congress defined and protected land. The act also served as the impetus for additional national environmental legislation. Congress passed the Wild and Scenic Rivers Act with the leadership of Nelson. President Lyndon B. Johnson signed the law that designated the Upper St. Croix as one of eight rivers in the act on October 2, 1968. The act protected the St. Croix to Taylors Falls at the southernmost while excluding, at the last minute, the Lower St. Croix. Senator Walter F. Mondale cosponsored the Lower St. Croix National Scenic Riverway in 1972, and President Richard M. Nixon signed the act that extended just north of Stillwater on October 25, 1972.

Finally, a "recreational segment" was added north of Stillwater to the confluence of the Mississippi River in 1976. McMahon and Karamanski

said, "Nearly a century later, Ray Stannard Baker's vision of a modern life balanced between urban amenities and natural landscape has come to fruition with the formation of the St. Croix National Scenic Riverway."

A six-month ban on land development on the fifty-two miles of St. Croix between Taylors Falls and Prescott, Wisconsin, was reported in the *Gazette* of January 12, 1973. Approved by the Minnesota Wisconsin Boundary Area Commission (MWBAC), the *Gazette* said of the resolution on October 19, 1973, "St. Croix River Association Seeks Additional Funding for Easements"; "a resolution was passed to ask all elected representatives of Minnesota and Wisconsin to request the Department of Interior to release Federal funds for the acquisition of additional scenic easement along the St. Croix River."

STILLWATER: NEW BRIDGES

Minnesota shares the St. Croix Valley with Wisconsin because Congress believed that the river was a natural boundary, a sentiment not shared by the original settlers of the St. Croix. They believed that there should be unity in the valley, and they fought vigorously to have the entire valley left outside Wisconsin (and thus potentially in Minnesota) when Wisconsin became a state. The movement failed, but the sense of regional identity remains. For once, hindsight and foresight agree, for political unity as was envisioned by the pioneer politicians of the St. Croix Valley would be an obvious advantage to the many thousands of Wisconsinites who work in the Twin Cities.
—*William E. Lass,* Minnesota: A History

STILLWATER IN THE 1960S AND 1970S

In the 1960s and 1970s, Stillwater created a nationally recognized historic district. Buildings were redeveloped for quirky independent businesses. Associate editor E.L. Roney, in the *Gazette* column "Looking Backward," established the historic preservation agenda with vivid articles on the city.

The 1965 flood demonstrated civic cohesion. In Stillwater on Easter Sunday, the St. Croix River crested at 694.07 feet (19.00 feet above average) above sea level—the highest recorded level. In the anthology *Stillwater, My Hometown and Yours*, in "The Flood of '65," a high school student working at Lakeview Hospital, Sharon Burnett Carrizales, recounted: "Several of

us decided this would be an interesting adventure, so we piled in Lucy's car after work and headed for Downtown Stillwater. There we found piles of sand in the parking lot and men and boys shoveling away, filling sandbag after sandbag to add to the piles." Students throughout the city prevented flooding. As Sherman said, "During the flood of 1965 on the St. Croix some of the inmates helped in building the sand dikes to hold back the water from the St. Croix." Tragedy was averted, but another high crest occurred in 1969. In "Historical Reconstruction of the Riverfront: Stillwater, MN," Norene A. Roberts said the 1965 and 1969 floods "would have caused extensive damage to all these buildings if the city had not undertaken an emergency flood fight."

In October 1962, the Washington County Courthouse was threatened when voters defeated the $1.5 million new courthouse bond. Dunn said "Minnesota's Oldest Courthouse…only temporarily postponed plans for a much-needed county building, which may or may not include preservation and historic restoration of the present landmark." He continued, "There are few buildings in all of Minnesota more worthy of preservation than the handsome Washington County Courthouse." He spearheaded the effort to spare the courthouse from the wrecking ball. "The Washington County Courthouse became the center of a controversy when in 1960, it became evident that the building was overcrowded," said Beverly J. Skoglund in *The Dream for Zion's Hill.* "Dunn influenced the County and State Historical Societies to support the move to preserve the courthouse." The director of the Minnesota Historical Society, Russell W. Fridley, supported him, and the National Historic Preservation Act was enacted in 1966. The new Washington County Courthouse was completed on March 16, 1968. The National Register of Historic Places designated the building on August 26, 1971.

In April 1975, concerned citizens formed the Washington County Historic Courthouse Foundation. The building was jointly operated by the foundation and county historical society. In 1982, the *Gazette* reported, "Historic Courthouse: For Rent" for fifty dollars per day (waived for nonprofits) with a one-hundred-dollar damage deposit. "Cultural activities" and, eventually, events were added as a source of revenue. At the Courthouse Theatre (CHT), for example, *The Miracle Worker* opened on February 16, 1982. The courthouse hosted countless tours, fundraisers, community outreach meetings and exhibits. In 2004, 222 events, including weddings, graduations, receptions and anniversaries, were held.

In Stillwater, historic renovations were widespread in the 1970s. Bookshops, presses and art galleries opened while sites were recognized

In 1970, the Grand Garage was an important early renovation; Stillwater Motors was revived as shops. *Sherman Wick.*

by the U.S. Department of the Interior. The federal government enacted the Historic Sites Act on August 21, 1935. The boom site was declared a National Historic Landmark on November 13, 1966.

The Grand Garage was an early renovation in Stillwater. In 1970, the old Stillwater Motors, on the southwest corner of Main and Olive Streets, was rehabbed. After serving in the Great War, Arthur Radeunz returned and sold cars in Withrow. In 1922, he relocated to downtown Stillwater and sold Buicks and Chevys—four hundred cars in 1928 and five hundred cars in 1929. In 1971, Stillwater Motors was a bellwether for community business when it relocated to a fifteen-acre site at the intersection of Minnesota State Highways 36 and 5. As McMahon and Karamanski said:

> *Despite all these efforts at preserving areas along the St. Croix River, it was not enough to protect the unique qualities of the river. By the mid-twentieth century the St. Croix River Valley began to take on a suburban quality, in part from the dramatic growth of communities on the river and its close proximity to Minneapolis and St. Paul.*

Over the years, the Stillwater Caves became a tourist destination. *The St. Croix Collection.*

The Freight House Restaurant was once the Milwaukee Road Depot. *Sherman Wick.*

In the 1970s, Minnesota State Highway 36, strip malls and new housing developments transformed the focus of downtown: tourism, renovations and bed-and-breakfasts replaced industry. In the mid-1940s, repurposing originated with Tom Curtis at the old Wolf Brewery; the local businessman "purchased the building, flooded the caves, stocked the pools with trout, and offered fishing and cave tours," said Doug Hoverson. The Freight House (233–335 Water Street) was rehabbed by Tom Blank with the financial support of Bob Sabes. The 1883 Chicago, Milwaukee & St. Paul Freight House was a brick depot of locally quarried limestone. It was listed in the National Register of Historic Places on July 13, 1977.

The Minnesota State Prison changed dramatically in the 1970s and 1980s. In 1973, only ninety of one thousand acres were retained. In the 1980s, the state's first level-five maximum-security prison, the Oak Park Heights Correctional Facility, was constructed on Osgood Avenue. The keynote speaker, Governor Al Quie, dedicated the four-hundred-bed prison on March 1, 1982. The prison's operational cost was $10 million in the inaugural year; however, it immediately earned money and relieved Wisconsin's overcrowded prisons. Wisconsin paid $50 per day for 50 inmates, then $55 in the second contract and $59 per day for 250 additional inmates.

THE RETURN OF THE STEAMBOAT ON THE ST. CROIX

In the nineteenth century, the primary conveyance was the steamboat. Pollution marred the beauty of the St. Croix. By the 1970s, industrial use of the river had declined, and riverboat cruises had recommenced.

In 1973, Griffith Marine Engineering purchased an excursion steamer, the *Jubilee I*. Traveling between the St. Croix and Stillwater, the eighty-five-by thirty-two-foot air-conditioned steamboat accommodated four hundred passengers. On January 2, 1973, Anita Buck wrote, "The romantic era of the steamboat on the St. Croix River will be recreated [*sic*] this summer." The chain-driven, diesel-powered sternwheeler was constructed by the Dubuque Boat & Boilerworks in 1963. "With the great history of steamboat travel on the St. Croix, such a service would be a significant attraction," said Vice President A. Carr Griffith.

For years, the St. Croix River Boat & Packet Company has offered paddle-wheel cruises from the port of Stillwater. *The Andiamo* was the newest paddle

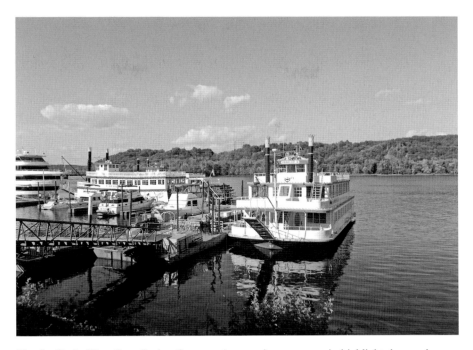

The St. Croix River Boat Packet Company's excursions once again highlight the scenic waterfront. *Sherman Wick.*

boat in 1985, under the ownership of Dick and Don Anderson. Ads stated that it was the "most luxurious Sternwheeler on the St. Croix," providing cruises both for lunch and dinner, with music and dancing.

LUMBERJACK DAYS

The first Lumberjack Days was celebrated on November 14, 15 and 16, 1934. Billed as "the Pioneer Celebration," the event reunited lumberjacks and revisited the halcyon days of the "Gay Nineties." The name was changed to Lumberjack Fête. The delegations, in period garb, competed in events: skiff and bateau races, logrolling and canoe tilting. Local and regional radio and government dignitaries attended to witness the floats and parade. The event culminated with sixty-five thousand attendees in 1940.

In 1941, World War II canceled the event. After the war, "Play Days," a summer celebration, showcased water shows, "Miss Stillwater" and

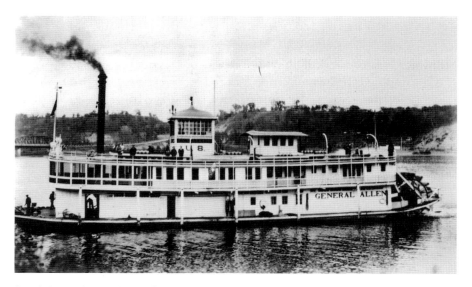

Scenic boat trips on the St. Croix declined with the advent of the automobile. *The St. Croix Collection.*

Downtown Stillwater was placed in the National Register of Historic Places in 1992. *Sherman Wick.*

"push mobile" races from 1949 until 1968. Diane Thompson quipped in *Lumberjack Day's Memories*, "Most non-residents hardly knew that Stillwater existed, and, if they did, it was often because the state prison was located near Stillwater."

In 1968, the return of Lumberjack Days signaled a municipal shift. The summertime event presented on the scenic St. Croix River included the "Boxcar Art Show," the "Old Fashioned Parade" and the dedication of the Washington County Courthouse historic marker. Lumberjack Days sponsored several historic events, such as "Save the Courthouse." Governor Rudy Perpich dedicated the Boomsite as a National Historic Site in 1978. The annual event expanded, but it was postponed for the yearlong sesquicentennial in 1993. Then, the Stillwater Chamber of Commerce declined financial support. In 1995, Stillwater native David Eckberg replaced local charm with huge regional concert events. But bills were unpaid, and Lumberjack Days ended after 2011. For a handful of years, the Stillwater Log Jam filled the void.

In an interesting footnote, the Stillwater City Council approved renaming the Stillwater Log Jam. Lumberjack Days is scheduled to return in 2016. The *Star Tribune* wrote on October 22, 2015, "Next year's festival under the Lumberjack Days name will continue the tradition intended when it was started in 1934...meaning no more rowdy celebrations." Mayor Ted Kozlowski pointedly concluded, "No one has any taste for that."

On March 26, 1992, the Stillwater Commercial District was placed in the National Register of Historic Places. Guidelines applied to the 1860s–1930s commercial district. Buildings in the vicinity of Main, Second and Chestnut Streets were federally protected.

MINNESOTA TERRITORIAL PRISON ARSON

The National Register of Historic Places recognized the Minnesota Territorial Prison in 1982. The prison relocated to South Stillwater while businesses reused the buildings that, over time, were neglected.

The Warden's House, a portion of the territorial prison, was preserved on June 20, 1941. The building reopened as the Washington County Historical Society (WCHS). Originally constructed in 1853, it was the residence of thirteen wardens until it closed in 1914. The county superintendent of schools, E.E. Bloomquist, organized the WCHS. The Boutwell's bell rang at the dedication on May 14, 1934. In December 1974, it was placed in the

The Warden's House is the only extant building from the historic Minnesota State Prison. *Sherman Wick.*

National Register of Historic Places. But seventy years later, the Warden's House narrowly avoided destruction.

The *Gazette* of September 4, 2002, reported in an article by Laura Brinkoetter, "Police Suspect Arson in Territorial Prison Fire." Firefighters responded from a dozen communities. She wrote, "Authorities suspect arsonists set a fire last night that destroyed in a towering blaze of flames a landmark structure at the site of Minnesota's oldest prison and dealt major losses to developers who wanted to convert existing buildings there into apartments and condominiums."

The tragedy occurred at 8:00 p.m. on Tuesday, September 3. When firefighters arrived, both buildings were "total losses" in the "worst fire in the area in years." Brinkoetter wrote, "For more than an hour, flames shot more than 100 feet in the air and could be seen for miles." She quoted Brent Peterson of the WCHS: "It's a tragedy that Minnesota has lost this history."

Suspects were arrested on September 6, 2002. Later, Peter Weyandt, an eighteen-year-old from St. Paul, was charged. He entered a plea agreement for 180 days in jail on September 3, 2003. On November 4, 2002, the *Gazette* reported that he "became bored and lit a piece of cardboard with a cigarette

lighter." The three-story twine factory was destroyed as well as a warehouse that dated from 1890.

Following the arson, outrage was expressed in the September 6 *Gazette*. Keith Dalluhn wrote a "Featured Letter" with the headline, "Territorial Prison Fire Destroyed More Than Bricks." The south Minneapolis resident was sickened. "I was driving home when I realized that I had just been to a funeral," said the author, who had played at Pioneer Park and Staples Field on the North Hill in his youth.

Only one item remained—bricks. The Washington County Historical Society sold 1,700 bricks from the territorial prison by November 4, 2002, and the sale continued. In 2005, three hundred rentals and condominiums were constructed on the site.

BRIDGING THE PAST TO THE PRESENT

Riding the craft beer boom, Lift Bridge and Maple Island Brewing Companies honor Stillwater's past. In 2007, the Minnesota state legislature passed the Surly Bill (HF 1326). The Lift Bridge Brewing Company was the first taproom in Minnesota in 2011. The antiquated post-Prohibition three-tier system that separated brewing, distribution and retail sale was overhauled when brewers produced quantities of beer within the state-regulated limit.

Iconic images of Stillwater inspired bottle art designs. For example, Lift Bridge's Commander barley wine ale was named after the eponymous grain elevator. At Nelson and Main Streets in 1898, the Commander Elevator was known as the Woodward Elevator Company. It relocated to the present site in 1904. Then, the Minnesota Flour Mill Company operated with a succession of ownerships until 1908. Finally, in 1961, the Commander Company was operated by Harvest States Co-op until March 1, 1984.

Maple Island Brewing resurrected craft brewing in downtown Stillwater in 2014. Maple Island beer honored local history, with the name of the creamery, hardware store and Isaac Staples's three-thousand-acre farm eleven miles northeast of Stillwater.

Moritz Bergstein, a Hungarian Jewish immigrant, operated the 1890 Shoddy Mill and Warehouse. He also owned, with his brother Ignatz, a Minneapolis mattress factory. In *St. Paul Pioneer Press*, Mary Divine wrote on March 26, 2015, "The mill, a single-story fieldstone structure, contained a machine called a 'devil' that turned rags into shoddy, a mattress stuffing.

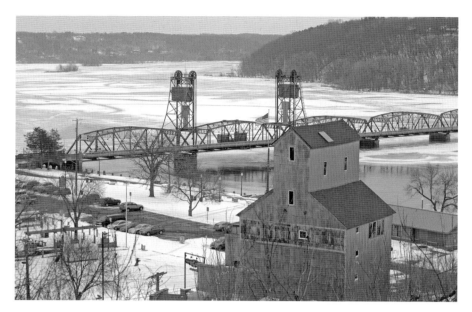

The iconic Commander Grain Elevator inspired the name of Lift Bridge Brewing Company's barley wine. *Sherman Wick.*

Maple Island Brewing is named after Isaac Staples's farm. Maple Island Creamery and hardware store were also once on this site. *Sherman Wick.*

In 2011, the Lift Bridge Brewing Company of Stillwater opened the first taproom in the state. *Sherman Wick.*

Fabric was stored in the warehouse." The property, located in the new St. Croix Crossing Bridge's right of way, was purchased from John Koller of Southside Repair, and the structures were relocated from Oak Park Heights to south of downtown Stillwater. The shoddy mill and warehouse exemplify a new attitude toward historic preservation. As Robert Vogel proposed in *Stillwater Historic Contexts:*

> *In the past, historic preservation in Stillwater has contributing [sic] to this limited (and limiting) vision by the emphasis on preserving large houses or commercial buildings financed with lumber capital, using stylized architecture as a major measure of significance (and, by implication, cultural achievement). Future surveys will recognize the richness and complexity of Stillwater's cultural heritage and the cultural resources produced by working class men and women.*

The Joseph Brown Trail serpentines along the old Minnesota Zephyr train corridor. In the fall of 2014, the 5.8-mile route opened. It complements the 18.0-mile Gateway Trail from St. Paul. The *Star Tribune*'s Kevin Giles wrote on June 4, 2015, "The Brown's Creek trail is expected to funnel 75,000

The Joseph Brown Trail links pedestrians and cyclists to the Gateway Trail and St. Paul. *Sherman Wick.*

people a year into Stillwater, many of them coming from the Gateway trail." The Lift Bridge is also linked with bicycle and pedestrian trails after receiving $12 million for rehabilitation.

William T. Boutwell Residence (1870) also reconnects the past with the present. The previous owner renovated the 4.8-acre site in 1981. The *Star Tribune* on May 29, 2015, wrote that $600,000 was paid for the property and "at least 300k more for restorations" was acquired by the Washington County Historical Society (WCHS). Nicole Curtis of HGTV's *Rehab Addict* intervened before the house was demolished. Then, the WCHS rescued the home. Mary Divine said in the *St. Paul Pioneer Press of* May 29, 2015, "The Washington County Historical Society already had in its collection two Bibles belonging to pioneer missionary William T. Boutwell, as well as the dinner bell he would ring as he walked the streets of Stillwater to call people to worship."

The St. Croix River Crossing is the biggest, longest-running and most controversial project in Stillwater's history. Donald Empson and Kathleen Vadnais in *Crossing the St. Croix River* went even further: "This bridge controversy, which was played out on the national stage, is probably the most significant event in the 150+ year history of Stillwater." It involved

two U.S. presidents, six cabinet members and a dozen U.S. congressmen in the "conflict."

Early historic preservation efforts reacted to the National Interstate and Defense Highway Act (1956). The federal freeway system indiscriminately mowed through neighborhoods and historic landmarks. In 1966, the National Historic Preservation Act designated historic places to counteract the previous act.

The new bridge was also a necessity. For decades, the Lift Bridge was incongruent with the region's population, economy and automobile traffic. State representative Howard Albertson issued the first rumblings of the insufficiency of the Stillwater Lift Bridge on June 26, 1967. The bridge averaged 7,000 automobiles and 850 trucks per day in 1969. In 1972, preliminary efforts to build a new bridge ended.

The Lift Bridge's shortcomings were outlined on March 2, 1982. *Gazette* editor Kevin Regan responded to *Parade Magazine*'s "18 worst bridges" in the nation. He said that the Federal Highway Administration estimated "replacement or rehabilitation" would then cost $61.9 million.

In 1987, local business leaders allied to defeat the bridge. Businessmen feared the new bridge would bypass downtown. In 1989, the daily vehicle count was projected to be 24,000 by 2010. But the Minnesota Department of Transportation (MnDOT) reported 16,600 vehicles per day by 2013.

Then, debate turned to the "Disposition of Existing Bridge" in 1990. Where to build the new bridge? MnDOT selected the "South Corridor" at Oak Park Heights on December 1, 1990—known to locals as "the Buckhorn Site" because of the restaurant lights that have been visible for years across the river in Wisconsin. Stillwater endorsed the South Corridor. Don Ahern wrote in the *St. Paul Pioneer Press* on March 5, 1991, "Businesses on Highway 36 Worried about Design Plans." Ahern continued, "merchants along the road south of the city have their fingers crossed that their stores and offices won't be strangled, first by years of construction and then by limited access from the high-volume road that attracted them there in the first place." In 1994, another hurdle was cleared: MnDOT, WisDOT and the Federal Highway Administration agreed on a bridge proposal. Land was acquired in Oak Park Heights for completion in 1999. Surprisingly, the National Park Service advocated demolishing the Lift Bridge. Jim Broede wrote in the *Pioneer Press* on March 15, 1995, that the $54 million "Stillwater Bridge Expected to Be Completed by 2000."

The Sierra Club filed a lawsuit; bridge construction ceased in 1996. The National Park Service "invoked" section 7(a) of the National Wild and

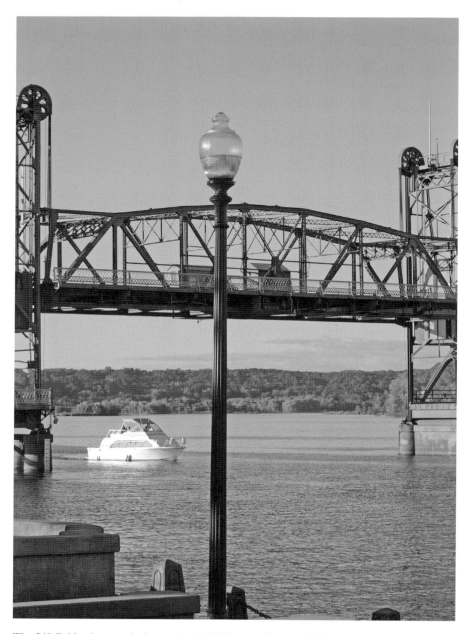

The Lift Bridge is an enduring symbol of Stillwater. *Sherman Wick.*

Scenic Rivers Act in December 1997. MnDOT idled the project, arguing that the massive scale of the bridge would undermine the river's scenic beauty. On April 13, 1998, District Court judge Ann Montgomery sustained the National Park Service veto.

In 2000, the National Park Service announced the preservation of the Lift Bridge. As the project's costs mushroomed, controversy continued over decades with federal court rulings and state funding issues. Divine said in the *Pioneer Press* of January 13, 2001, "Work on Bridge Comes to Screeching Halt." Minnesota and Wisconsin suspended construction on the $135.5 million freeway-style bridge. Meanwhile, columnist Ken Wisneski wrote in the *Gazette* on October 9, 2002: "Contrary to what cynics say, the U.S. Senate and the United Nations will not need to sanction a war in order for thousands of folks a day to zoom right past our humble outpost without stopping." Furthermore, he said, "I think traffic is a sign of commercial health. Hugo, for example, does not have a lot of traffic, nor is it a tourist mecca." He concluded, "let us all hope that the bridge to Stillwater East is not…a Bridge too far."

The bridge was one of seven projects with "accelerated environmental reviews." On November 1, 2002, the *Gazette* headlined, "Feds Put Stillwater Bridge Project on the Fast Track." Minnesota's and Wisconsin's transportation departments agreed on a bridge project.

The bridge debate developed on new lines: government and business versus environmentalists. "Environmentalists oppose a plan to build a freeway-style bridge over the river. They say it would accelerate urban sprawl from the Twin Cities into western Wisconsin," wrote the *Gazette* on November 1, 2002. In the *Gazette* of November 4, 2002, Mary E. Peters, the Federal Highway Administrator, disagreed: "The St. Croix River Crossing projects will improve safety and enhance mobility and economic development in both Minnesota and Wisconsin."

The National Park Service blocked the St. Croix River Bridge project on March 11, 2010. U.S. representatives Michele Bachmann of Minnesota and Sean Duffy and Ron Kind of Wisconsin introduced a bill to override the National Wild and Scenic Rivers Act for the $668 million project. The bridge in October stalled because of the National Park Service, "protected by the U.S. Wild and Scenic Rivers Act." Walter Mondale angrily said the law that he cosponsored with Gaylord Nelson was not an "advisory suggestion," and applauded the park service for enforcing the Wild and Scenic Rivers Act.

Senators Amy Klobuchar and Al Franken of Minnesota introduced a similar Senate bill supported by Herb Kohl and Ron Johnson of Wisconsin

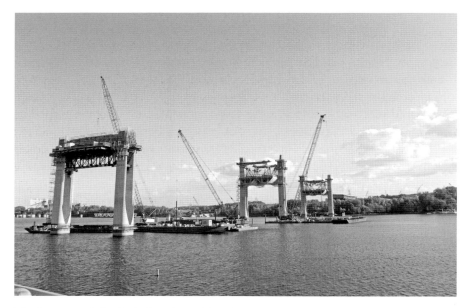

The freeway-style St. Croix Crossing Bridge will someday transform Stillwater. *Sherman Wick.*

Downtown Stillwater has evolved from a lumber town to a regional tourism and recreation area. *Sherman Wick.*

on May 26, 2011. By then, Stillwater civic leaders had lobbied for a four-lane structure connecting Highway 36 at Oak Park Heights with Highway 64 in St. Joseph, Houlton and St. Croix Counties. On March 14, 2012, President Obama exempted the bridge from the National Wild and Scenic Rivers Act.

The complexity of the St. Croix Crossing Bridge has delayed completion. The extradosed bridge combines cable-stayed and girder bridge design. The *Minneapolis Star Tribune* reported on September 5, 2015, that it was predicted that "delay may add costs" to the "$676 million bridge." Commissioner Charlie Zelle of MnDOT said, "This is a very complex engineering project....This is only the second major bridge of its type in the United States and the methods of construction are taking longer than anticipated." Then, the *Pioneer Press* reported on January 6, 2016: "From flooding and an early cold snap to major equipment failures, the St. Croix River bridge project has faced one problem after another." The completion date was delayed until the fall of 2017.

Empson and Vadnais mused, "Will this $700 million bridge (and all the improvements on highway 36) prove to be a blessing or a curse?" McMahon and Karamanski, wrote about the St. Croix River:

> *Rivers are highways that bring together people from distant places. Rivers also serve as barriers and boundaries. In the seventeenth century, the St. Croix River brought the Ojibwe invaders who, after a century of bloodshed, drove the Dakota from the land of their fathers. In more recent times the river has brought—thanks to U.S. Army Corps of Engineers, lock and dam projects, and global trade patterns—invaders from the Baltic Sea, in the form of zebra mussels. For this exotic species, like human immigrants from Europe before them, the St. Croix has been a river of opportunity as new colonies flourish and indigenous populations are vanquished from a transformed ecosystem.*

SELECTED BIBLIOGRAPHY

Atkins, Annette. *Creating Minnesota: A History from the Inside* Out. St. Paul: Minnesota Historical Society Press, 2007.

Blair, W.A. *A Raft Pilot's Log.* Cleveland: Arthur H. Clark Company, 1919.

Blegen, Theodore C. *Minnesota: A History of the State.* 2nd ed. Minneapolis: University of Minnesota Press, 1975.

Bond, J.W. *Minnesota and Its Resources.* New York: Redfield, 1853.

Boorstin, Daniel J. *The Americans: The National Experience.* New York: Vintage Books, 1965.

Bray, Martha Coleman, ed. *The Journals of Joseph N. Nicollet: A Scientist on the Mississippi Headwaters, with Notes on Indian Life.* St. Paul: Minnesota Historical Press, 2009; reprint of 1970 edition.

Buck, Anita A. *Jo Lutz and the Stillwater Art Colony.* Bayport, MN: Bayport Printing House, 1997.

———. *Steamboats on the St. Croix.* St. Cloud, MN: North Star Press, 1990.

Clemens, Kevin. *Carnegie Libraries of Minnesota.* Lake Elmo, MN: Demontreville Press, 2011.

Conzen, Kathleen Neils. *Germans in Minnesota.* St. Paul: Minnesota Historical Society, 2003.

Dick, Charles. "A Geographical Analysis of the Development of the Brewing Industry of Minnesota." PhD dissertation, University of Minnesota, 1981.

Diers, John W., and Aaron Isaacs. *Twin Cities Trolley: The Streetcar Era in Minneapolis and St. Paul.* Minneapolis: University of Minnesota Press, 2007.

Dunn, James Taylor. *Saving the River: The Story of the St. Croix River Association, 1911–1986.* St. Paul, MN: St. Croix Association, 1986.

———. *The St. Croix: Midwest Border River.* St. Paul: Minnesota Historical Press, 1979.

Easton, Augustus B., ed. *History of the St. Croix Valley.* Chicago: H.C. Cooper, Jr. & Co., 1901.

Ellet, Elizabeth F. *Summer Rambles in the West.* New York: J.C. Riker, 1853.

Empson, Donald, comp. *Dutchtown Residential Area: Stillwater, Washington County, Minnesota.* Stillwater, MN: Heritage Preservation Commission, 1998.

———. *The East Half of the Churchill, Nelson & Slaughter Addition Residential Area, Stillwater, Washington County, Minnesota.* Stillwater, MN, 2003.

———. *Hersey, Staples Residential Area: Stillwater, Washington County, Minnesota.* Stillwater, MN, 2000.

———. *History of the Holcombe's Addition Residential Area: Stillwater, Minnesota.* Stillwater, MN, 1998.

Empson, Donald, and Kathleen Vadnais. *Crossing the St. Croix: The 45-Year Struggle to Build a New Stillwater Bridge and Save the Historic Lift Bridge.* N.p.: self-published, 2015.

Farrar, Maurice. *Five Years in Minnesota: Sketches of Life in a Western State.* London: Sampson, Low, Marston, Searle & Rivington, 1880.

First Presbyterian Church: Album. Self-published, no date.

Flandrau, Charles E. *The History of Minnesota and Tales of the Frontier.* St. Paul, MN: E.W. Porter, 1900.

Folsom, William H.C. *Fifty Years in the Northwest.* St. Paul, MN: Pioneer Press, 1888.

Folwell, William Watts. *A History of Minnesota in Four Volumes.* St. Paul: Minnesota Historical Society, 1956, 1961, 1969.

———. *The North Star State.* New York: Houghton Mifflin Co., 1908.

Garraty, John A., and Mark C. Carnes. *A Short History of the American Nation Vols 1 & 2.* New York: Addison, Wesley, Longman, 2001.

Goodman, Nancy, and Robert Goodman. *Joseph R. Brown: Adventurer on the Minnesota Frontier 1820–1849.* Rochester, MN: Lone Oak Press, 1996.

Graves, Kathy Davis, and Elizabeth Ebbott. *Indians in Minnesota.* Minneapolis: University of Minnesota Press, 2006.

Hage, George S. *Newspaper on the Minnesota Frontier, 1849–1860.* St. Paul: Minnesota Historical Society, 1967.

Hart, John Fraser, and Susy Svatek Ziegler. *Landscapes of Minnesota: A Geography.* St. Paul: Minnesota Historical Society Press, 2008.

Heilbron, William C. *Convict Life at the Minnesota State Prison*. Stillwater, MN: Valley History Press, 1996.

Holmquist, June Drenning, ed. *They Chose Minnesota: A Survey of the State's Ethnic Groups*. St. Paul: Minnesota Historical Press, 1981.

Hoverson, Doug. *Land of Amber Waters: The History of Brewing in Minnesota*. Minneapolis: University of Minnesota Press, 2007.

Josephson, Matthew. *Robber Barons*. New York: Harcourt Inc., 1962.

Kaplan, Anne R., and Marilyn Ziebarth, eds. *Making Minnesota Territory 1849–1858* (special edition to *Minnesota History* magazine). St. Paul: Minnesota Historical Press, 1999.

Karamanski, Theodore J., and Eileen M. McMahon. *North Woods River: The St. Croix River in Upper Midwest History*. Madison: University of Wisconsin Press, 2009.

Kellogg, Louise Phelps. *The French Regime in Wisconsin and the Northwest*. Madison: State Historical Society of Wisconsin, 1925.

Kenney, Dave, and Thomas Saylor. *Minnesota in the '70s*. St. Paul: Minnesota Historical Press, 2013.

Koutsky, Kathryn, and Linda Koutsky. *Minnesota Vacation Days*. St. Paul: Minnesota Historical Press, 2006.

Larson, Agnes M. *The White Pine Industry: A History*. Minneapolis: University of Minnesota Press, 2007.

Lass, William E. *Minnesota: A History*. 2nd ed. New York: W.W. Norton and Company, 1998.

Lyseth, Alaina Wolter. *Hinckley and the Fire of 1894*. Charleston, SC: Arcadia Publishing, 2014.

Mann, Charles C. *1491: New Revelations of the Americas Before Columbus*. New York: Vintage Books, 2011.

Mason, Philip, ed. *Schoolcraft's Expedition to Lake Itasca*. East Lansing, MI: Michigan State University Press, 1993.

Merrick, George B. *Old Times on the Upper Mississippi: The Recollections of a Steamboat Pilot from 1854 to 1863*. Cleveland, OH: Arthur H. Clark Company, 1909.

The Minnesota Guide. St. Paul, MN: E.H. Burrit & Smp. Co., 1869.

Moore, Nathaniel Fish. *A Trip from New York to the Falls of St. Anthony in 1845*. Chicago: University of Chicago Press, 1946. Reprint, ed. by Stanley Pargellis and Ruth Lapham Butler.

Morris, Lucy Leavenworth Wilder. *Old Rail Corners: Frontier Tales Told by Minnesota Pioneers*. 2nd ed. St. Paul: Minnesota Historical Press, 1976.

Neill, Edward D. *Concise History of the State of Minnesota*. Minneapolis: Harrison Smith, 1887.

Neill, Edward D., and George E. Warner. *History of Hennepin County and the City of Minneapolis*. Minneapolis, MN: North Star Publishing Co., 1881.

Roberts, Norene. *North Hill (Original Town) Stillwater Residents in Area: Stillwater, Washington County, Minnesota*. Minneapolis, MN: Historical Research, Inc., 1995.

Roney, E.L. *Looking Backward*. Roney Memorial Fund, 1970.

Rosenfelt, William T., gen. ed., and Maynard Johnson, assoc. ed. *Washington: A History of the County*. Stillwater, MN: Croixside Press, 1977.

Russell, Charles Edward. *A-Rafting on the Mississippi*. New York: Century Company, 1928.

Sherman, Hila. *Bayport: Three Little Towns on the St. Croix (1842–1976)*. Hudson, WI: Star-Observer Publishing Company, 1976.

Skoglund, Beverly J. *The Dream for Zion's Hill: Washington County Historic Courthouse*. Stillwater, MN: Washington County Historic Courthouse, 1994.

Stillwater Historic Contexts: A Comprehensive Learning Approach. Stillwater, MN: Robert C. Vogel & Associates, 1993.

Stillwater, My Hometown and Yours. Stillwater, MN: American Legion & Chamber of Commerce & Lumberjack Days, 1989.

Sullivan, Sir Edward Robert. *Rambles and Scrambles in North and South America*. London: Richard Bentley, 1852.

Thilgen, Dean R. *Valley Rails: A History of Railroads in the St. Croix Valley*. N.p.: self-published, 1990.

Thompson, Diane, ed. *First Presbyterian Church*, paper.

———. *Memories of Stillwater's Lumberjack Days Celebrations: 1934–1995*. Stillwater, MN: Washington County Historical Society, 2010.

Warner, George E., and Charles M. Foote, eds. *History of Washington County and the St. Croix Valley*. Minneapolis: North Star Publishing Company, 1881.

Winchell, N.H. *The Aborigines of Minnesota*. St. Paul: The Minnesota Historical Society, 1911.

Wingerd, Mary Lethert. *North Country: The Making of Minnesota*. Minneapolis: University of Minnesota Press, 2010.

Younger, Cole. *The Story of Cole Younger*. St. Paul: Minnesota Historical Society Press, 2000 (reprint from 1903).

NEWSPAPERS AND PERIODICALS

Bayport Herald
Bayport Photo News

Minneapolis Journal
Minneapolis Tribune
Minnesota History Magazine (Vols. 9, 10, 18, 24, 37, 38, 53, 55, 56)
Minnesota Pioneer
Mississippi Valley Lumberjack
Prison Mirror
Rube's Advocate
St. Croix Post
St. Croix Union
St. Paul Dispatch
Stillwater Democrat
Stillwater Gazette
Stillwater Messenger
Stillwater News
Stillwater Republican
Stillwater Sun Daily
Taylors Falls Journal
Washington County Journal

INDEX

Y

ABOUT THE AUTHORS

Holly Day and Sherman Wick have cowritten several books about the Twin Cities, including multiple editions of *The Insider's Guide to the Twin Cities*, *Walking Twin Cities* and *Nordeast Minneapolis: A History*. Sherman Wick received his BA in history from the University of Minnesota and has been a member of the Minnesota Historical Society for several decades. Holly Day has worked as a freelance writer for local and national publications over twenty-five years and teaches writing classes at the Loft Literary Center.